Experience Design Coloring Book, Volume I

Inspired Designs & Coloring Patterns

Josie Gluck

© 2016 Josie Gluck
All Rights Reserved.

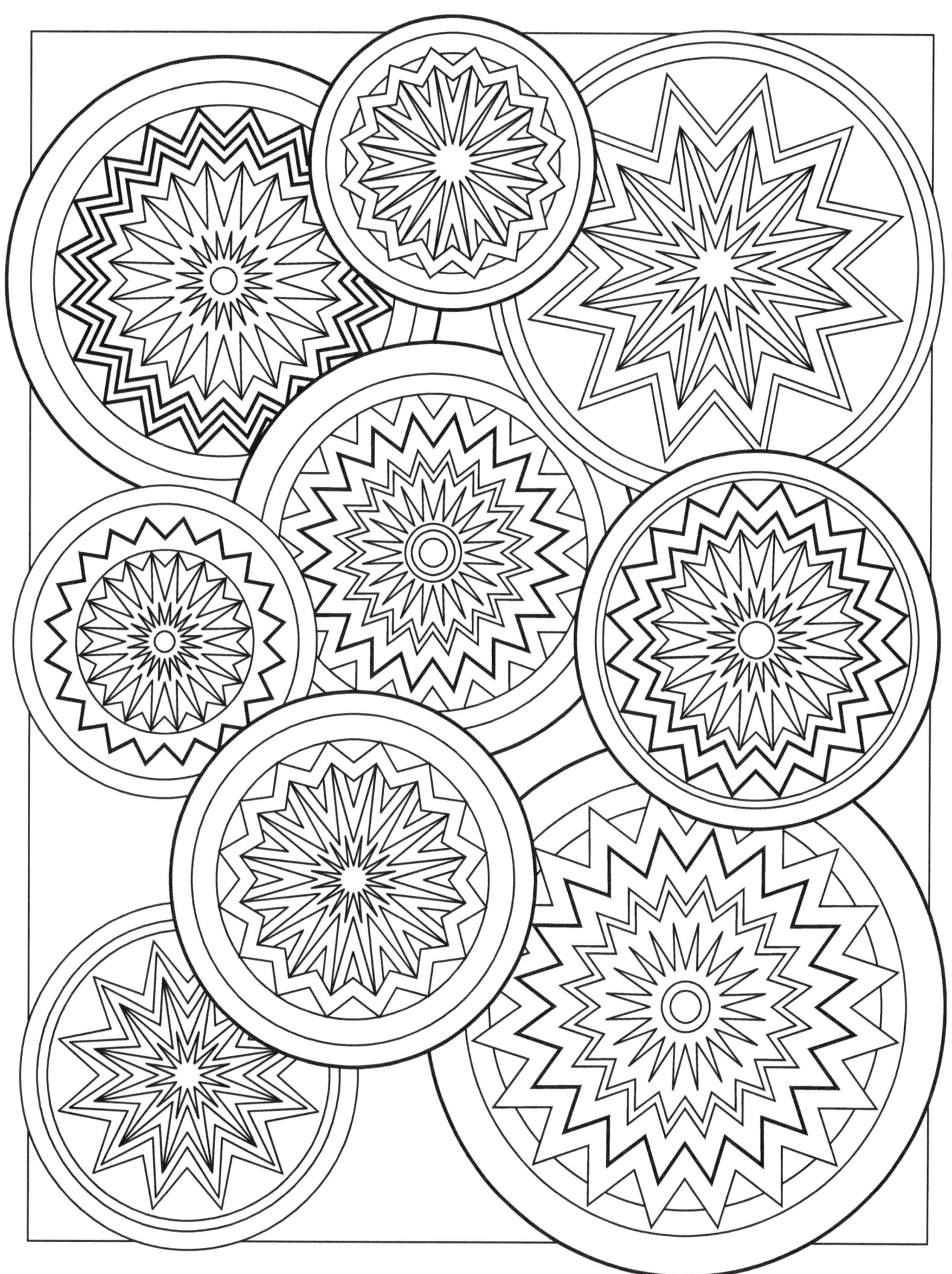

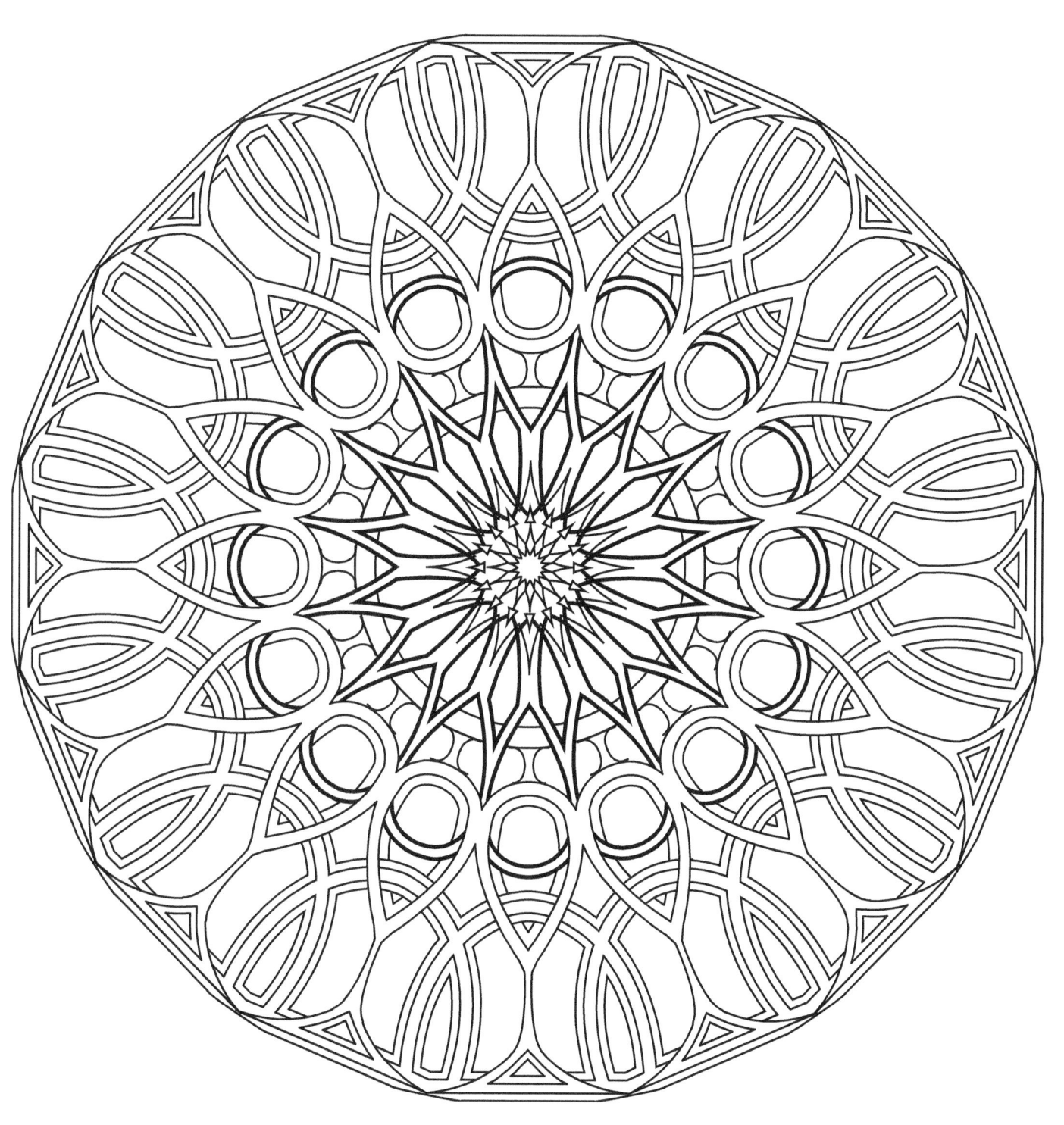

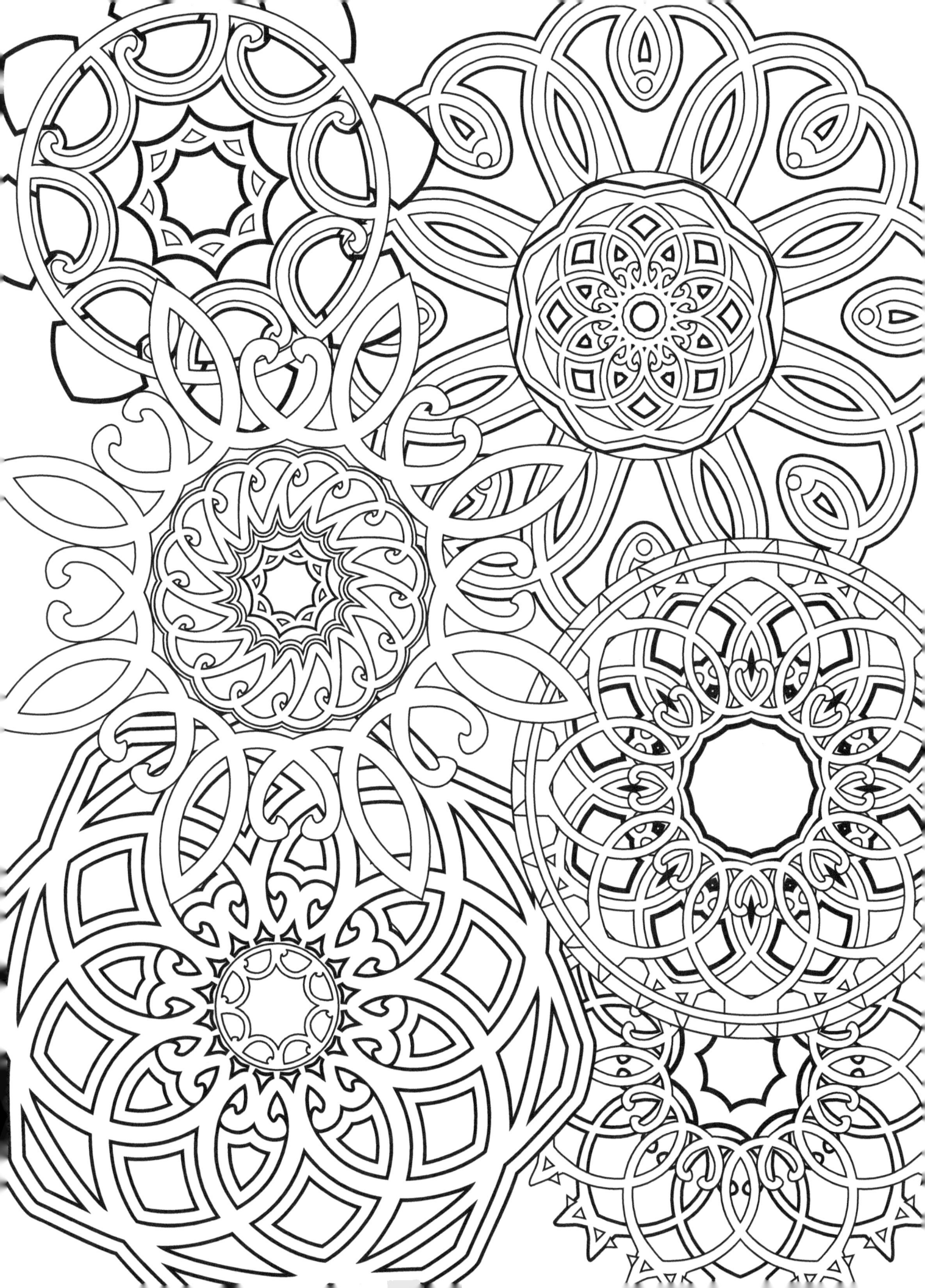

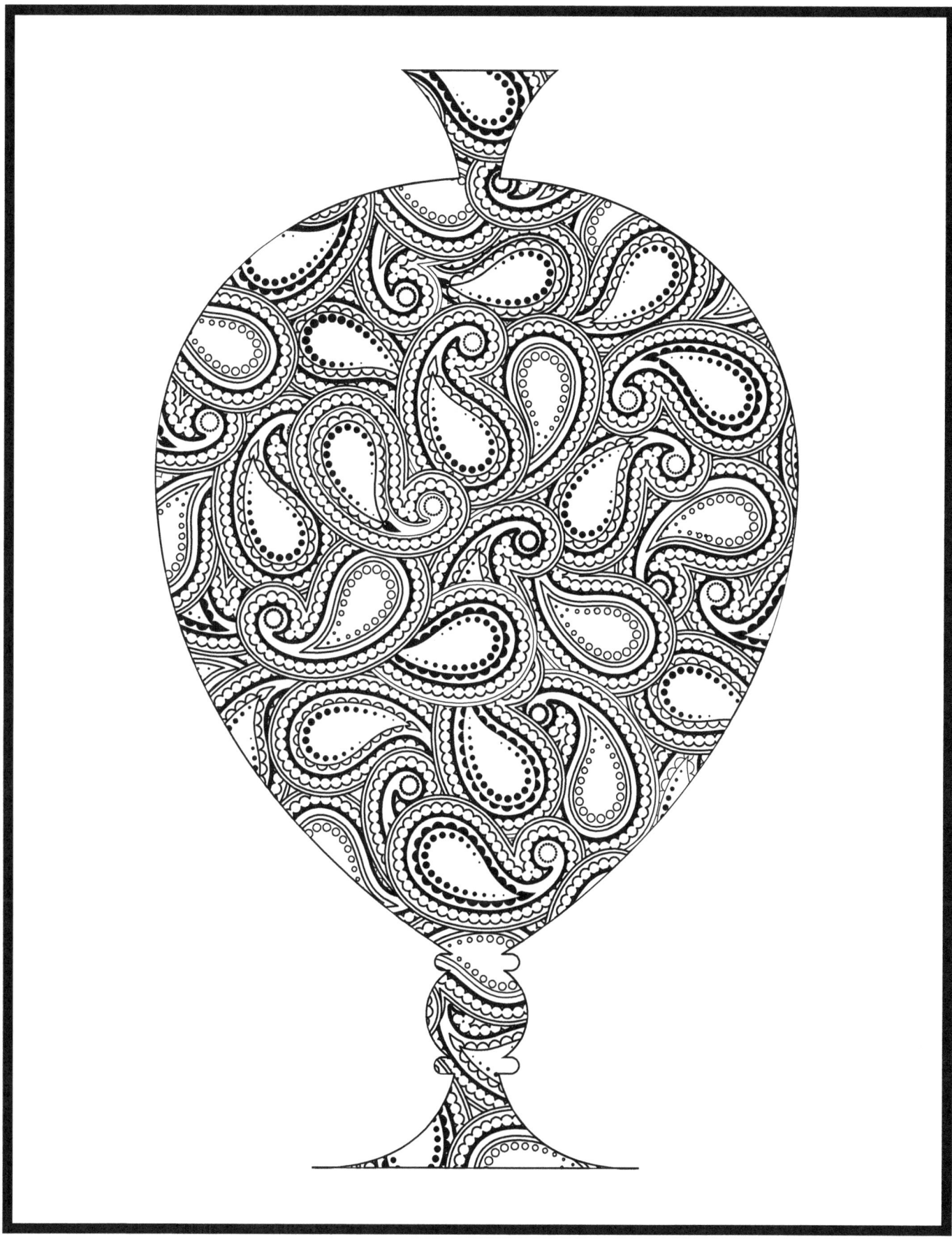

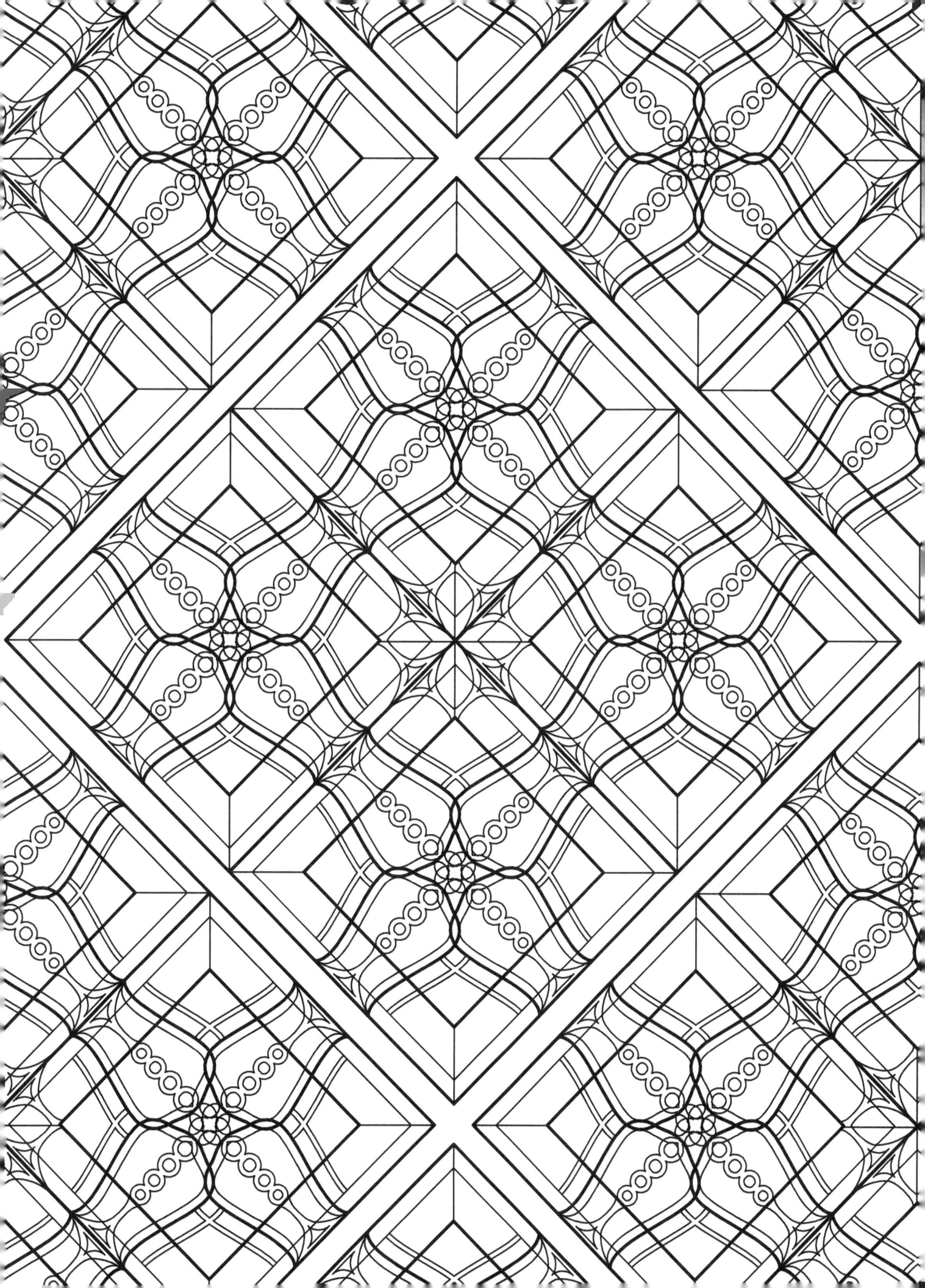

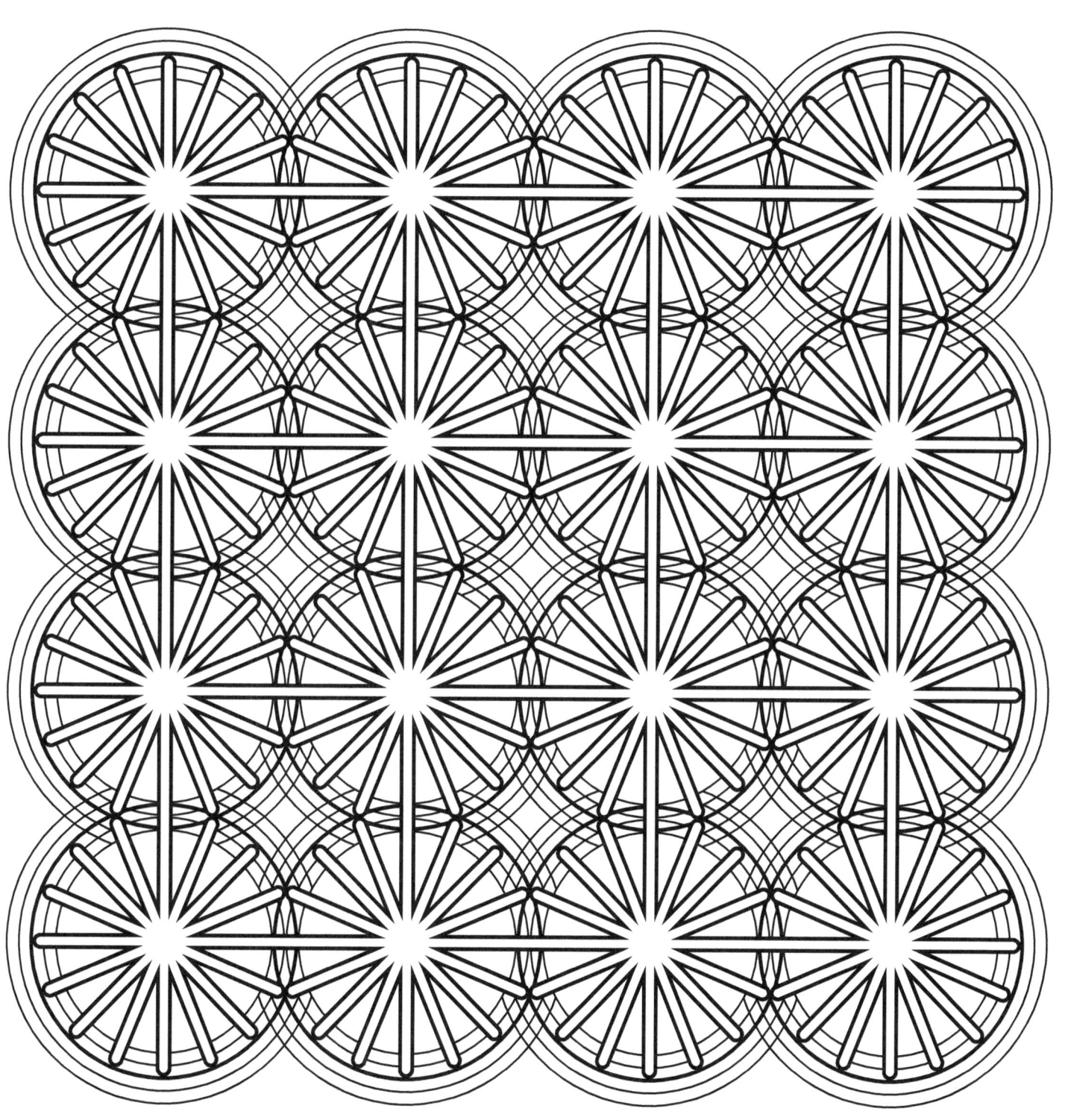

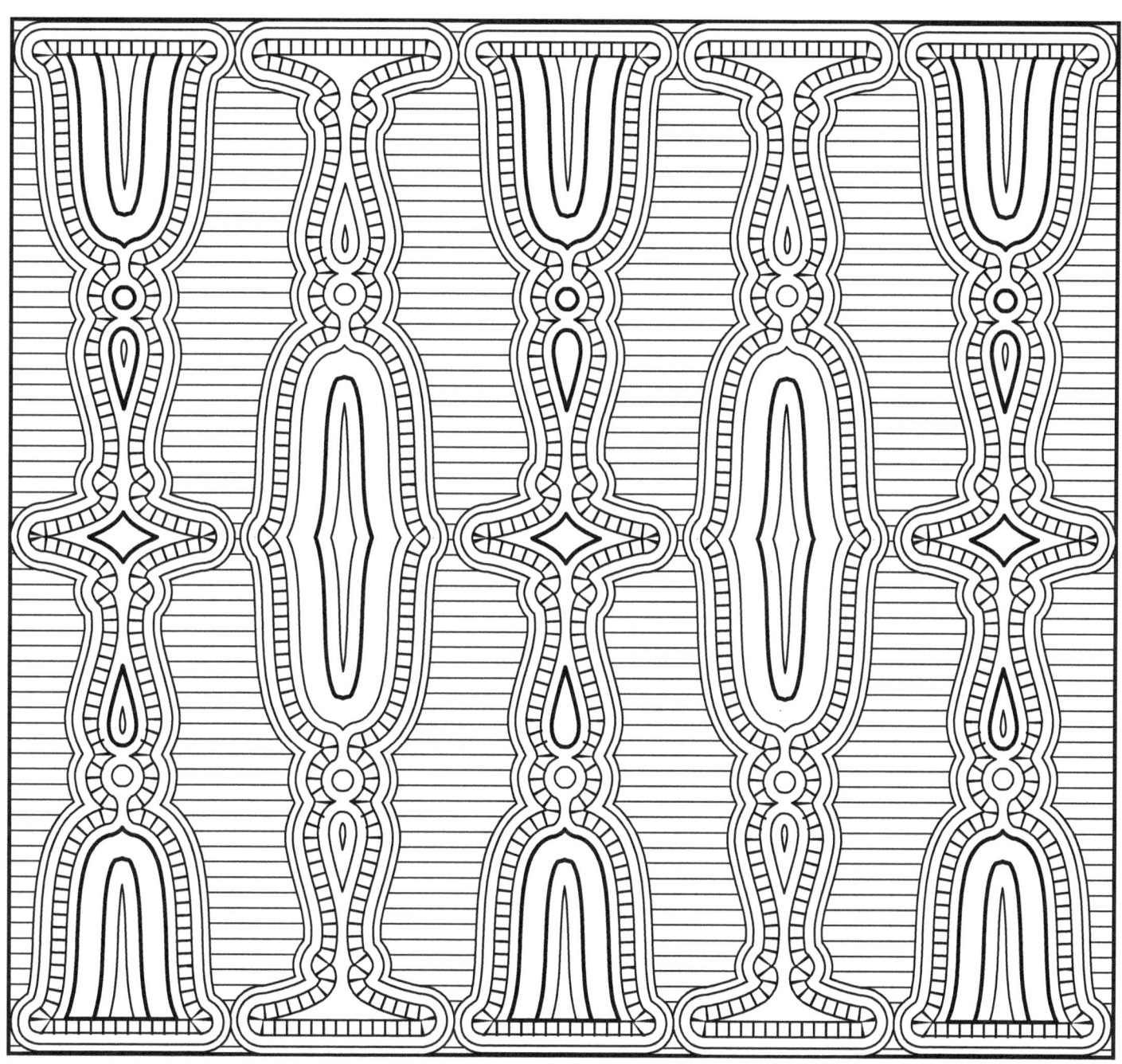

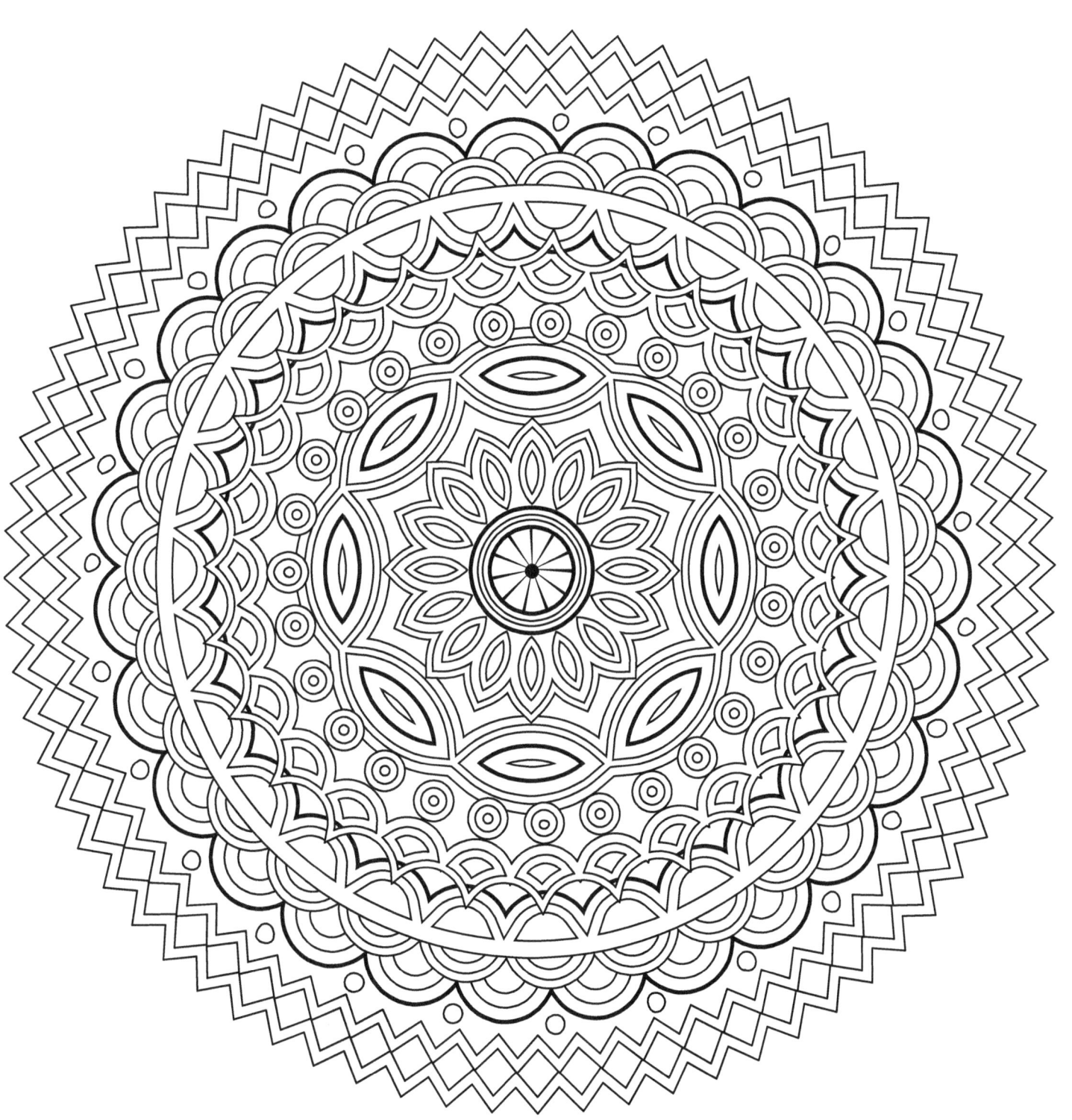

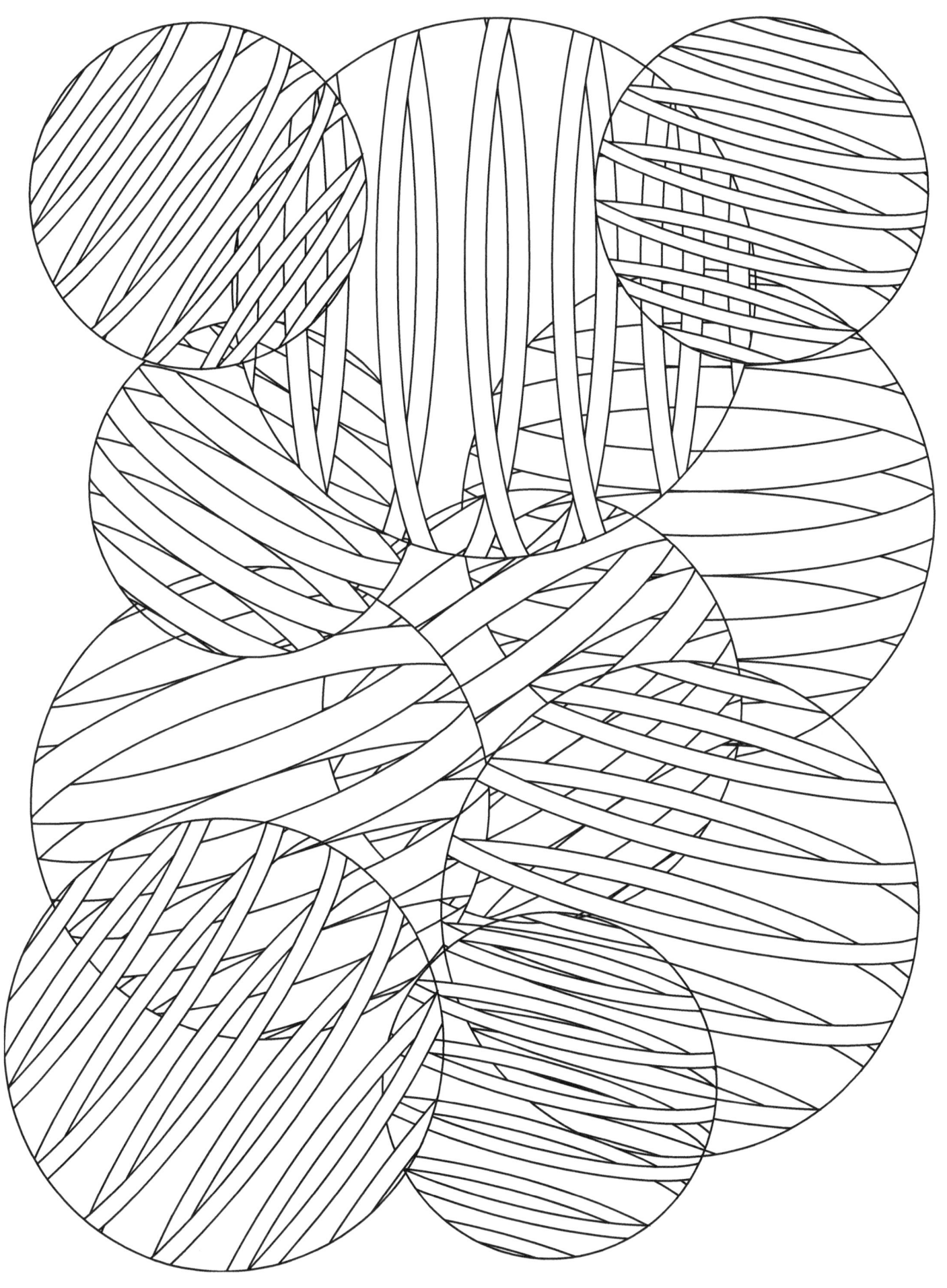

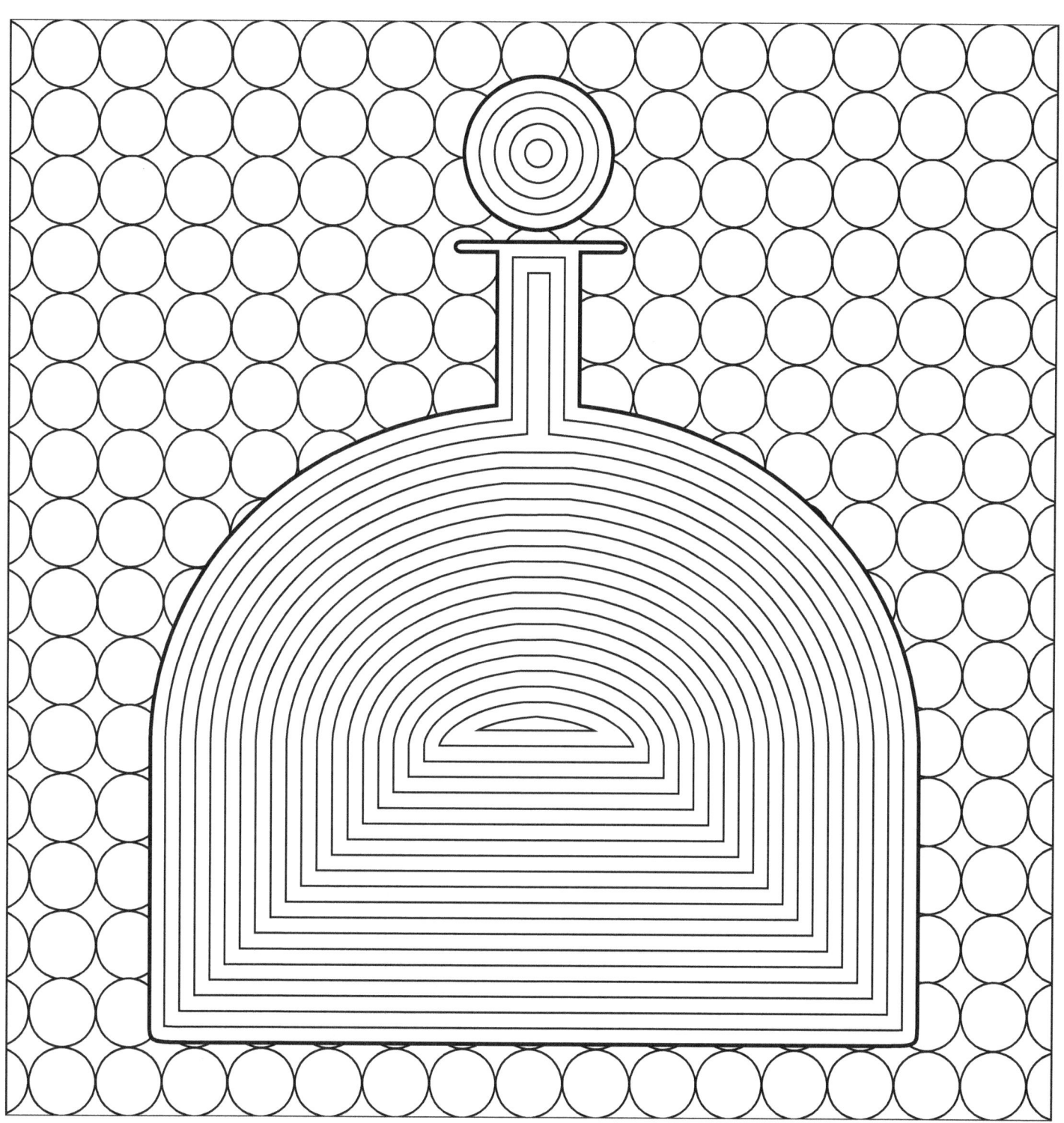

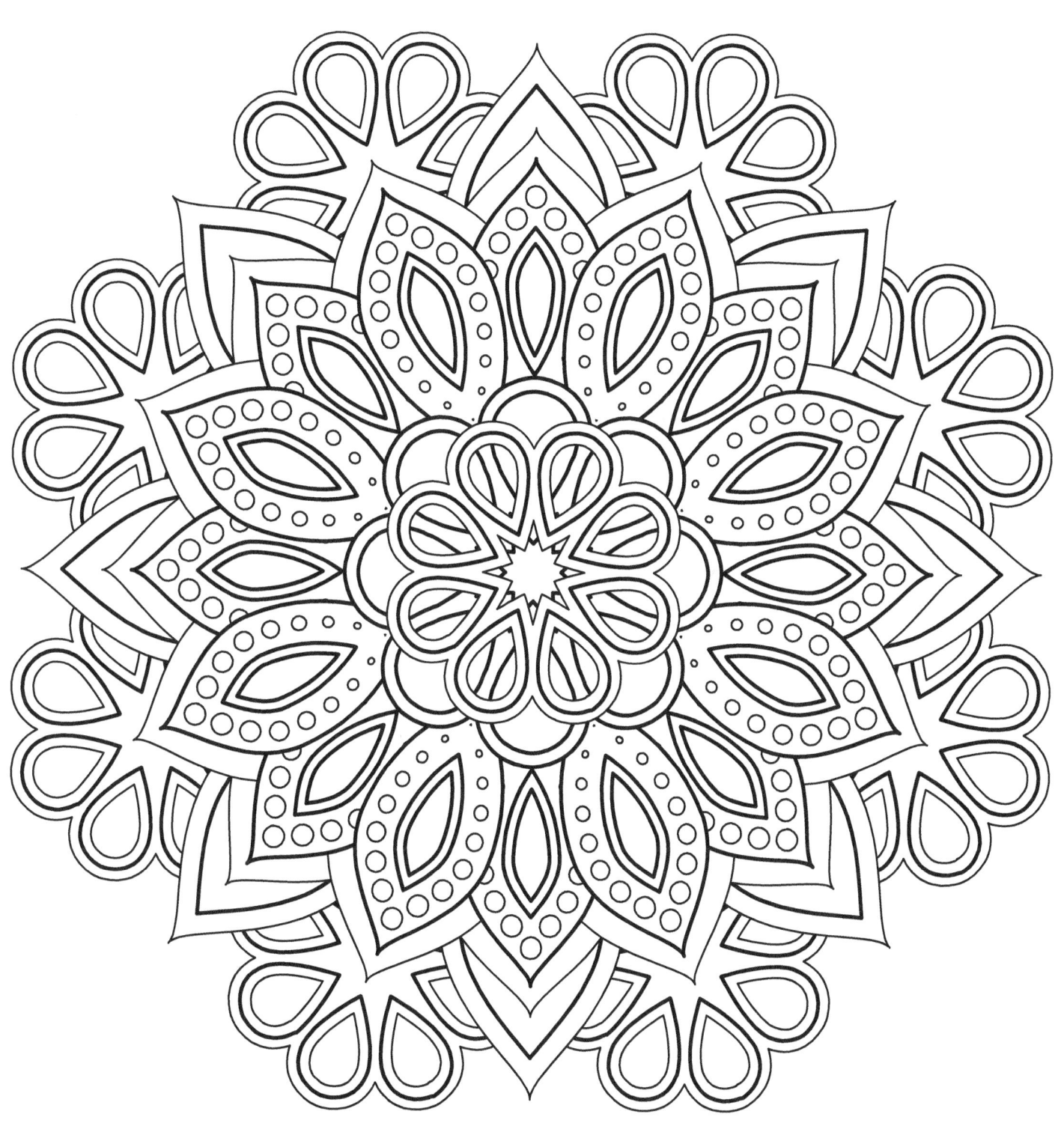

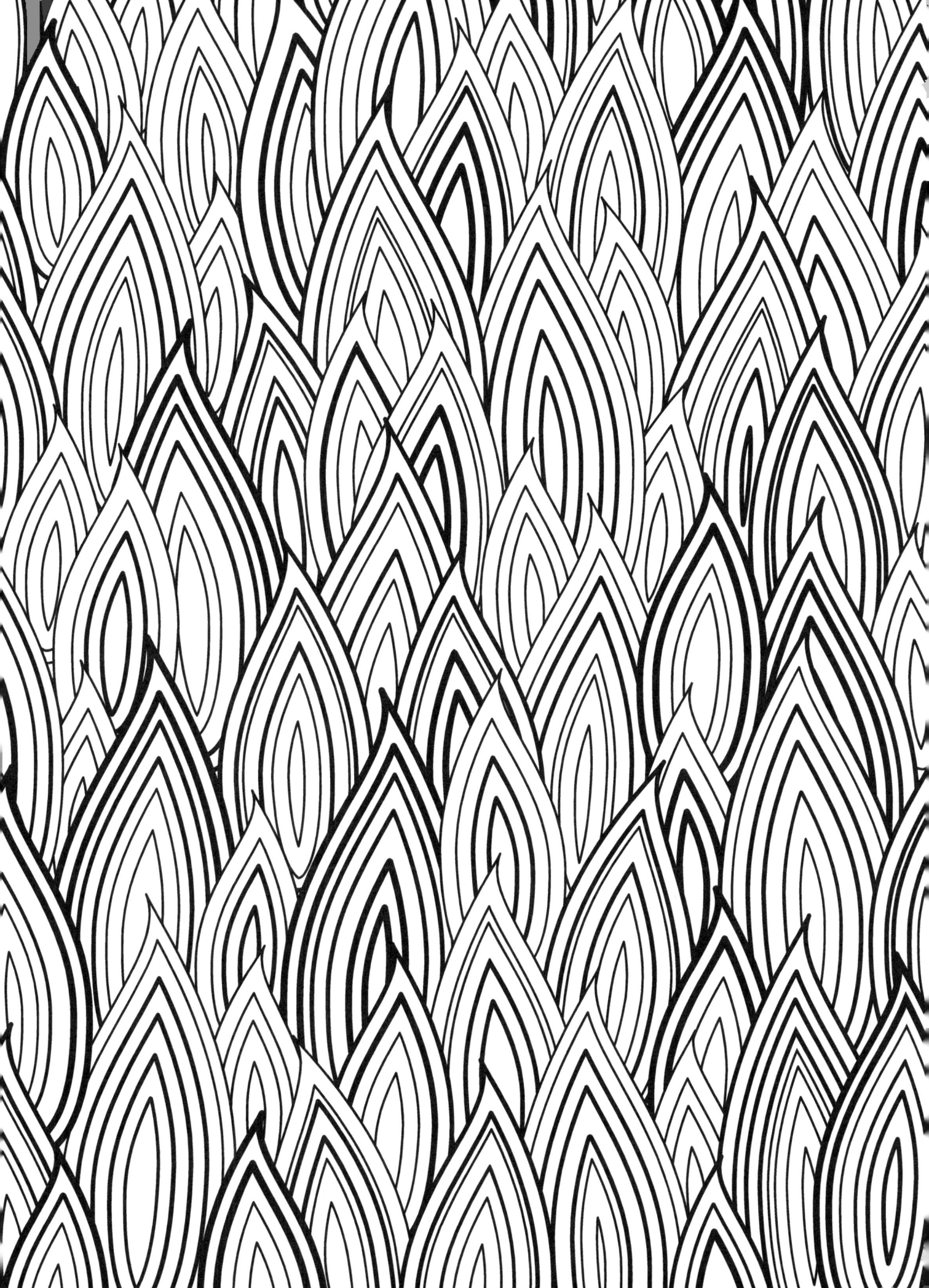

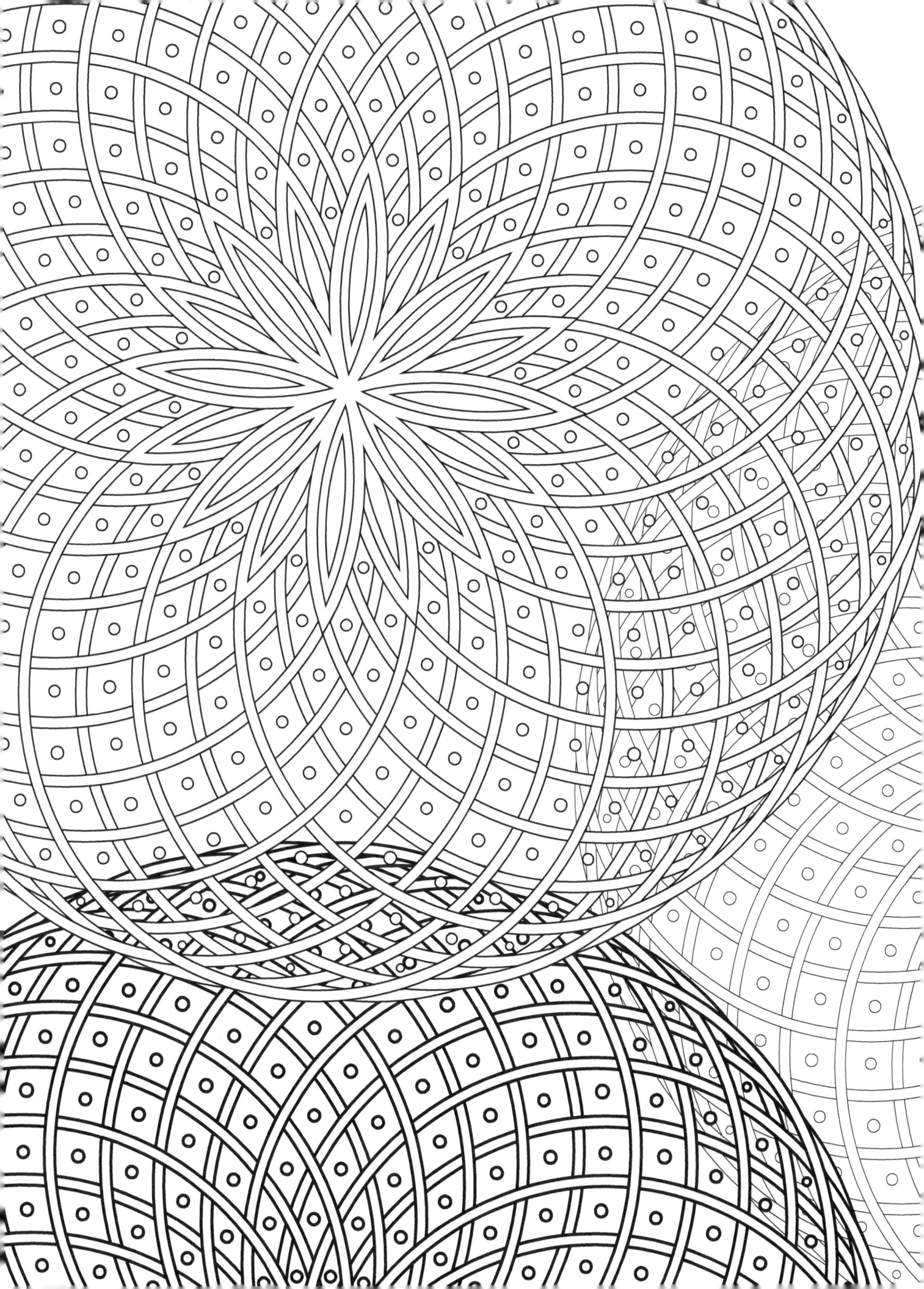

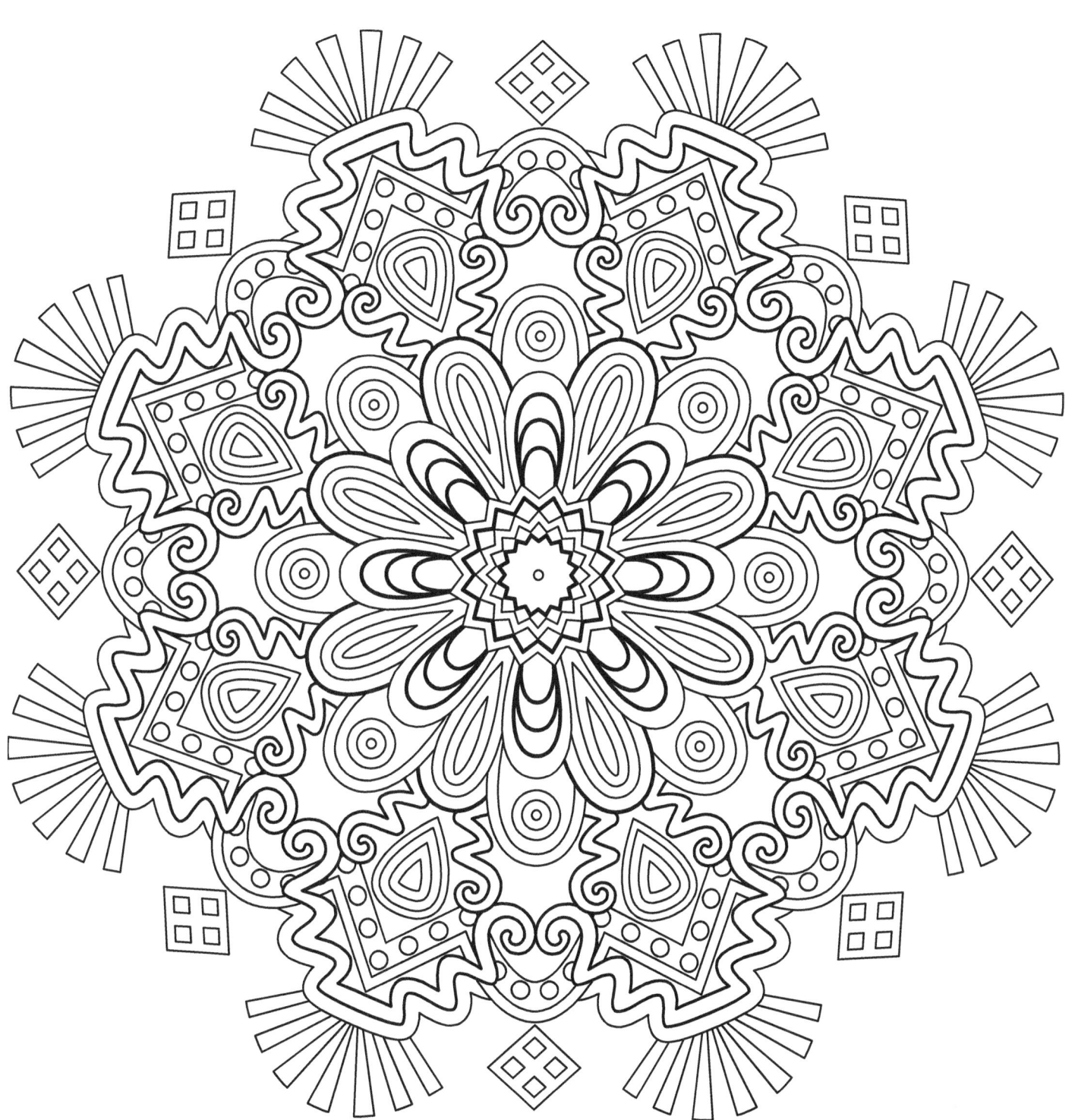

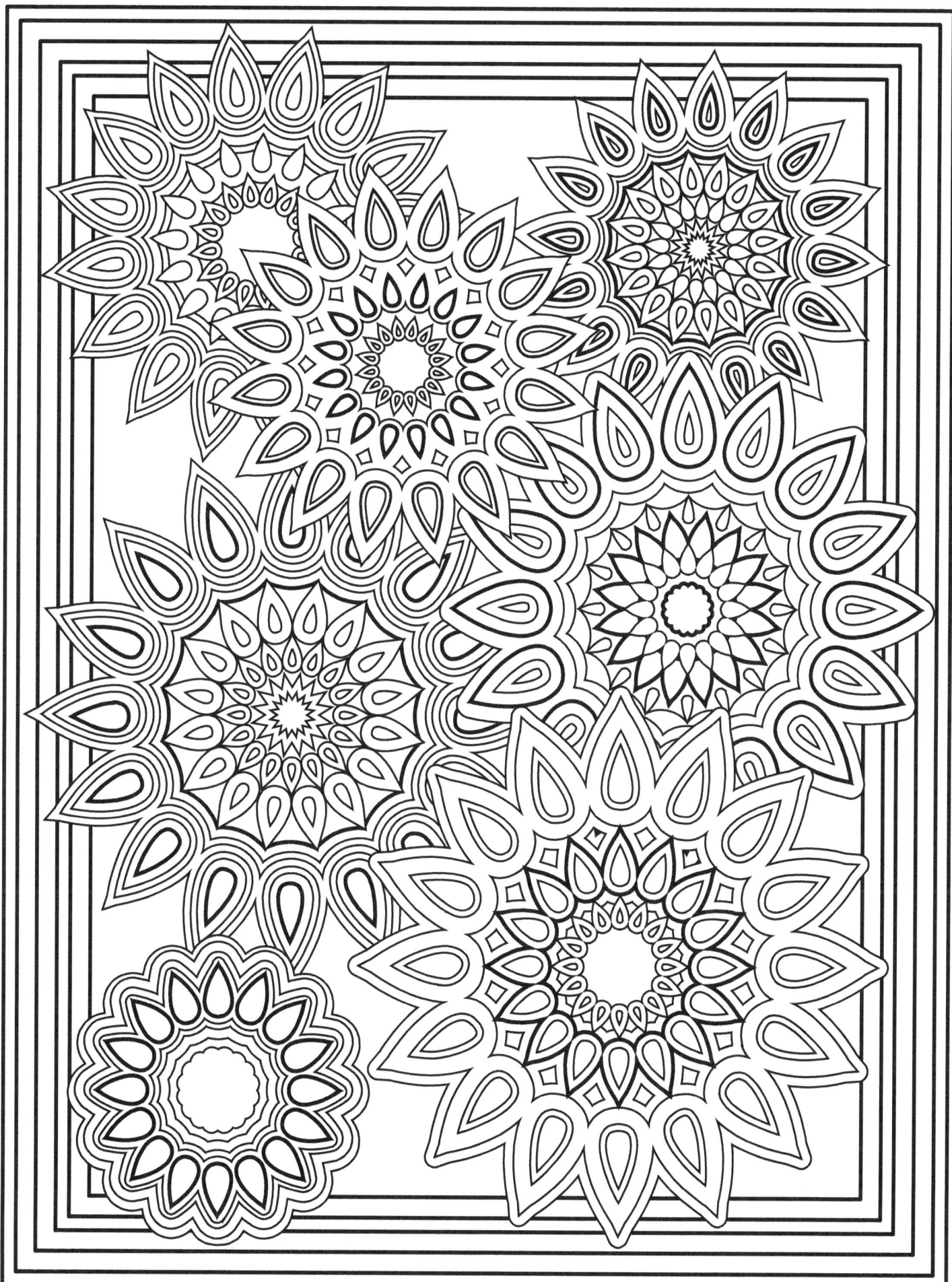

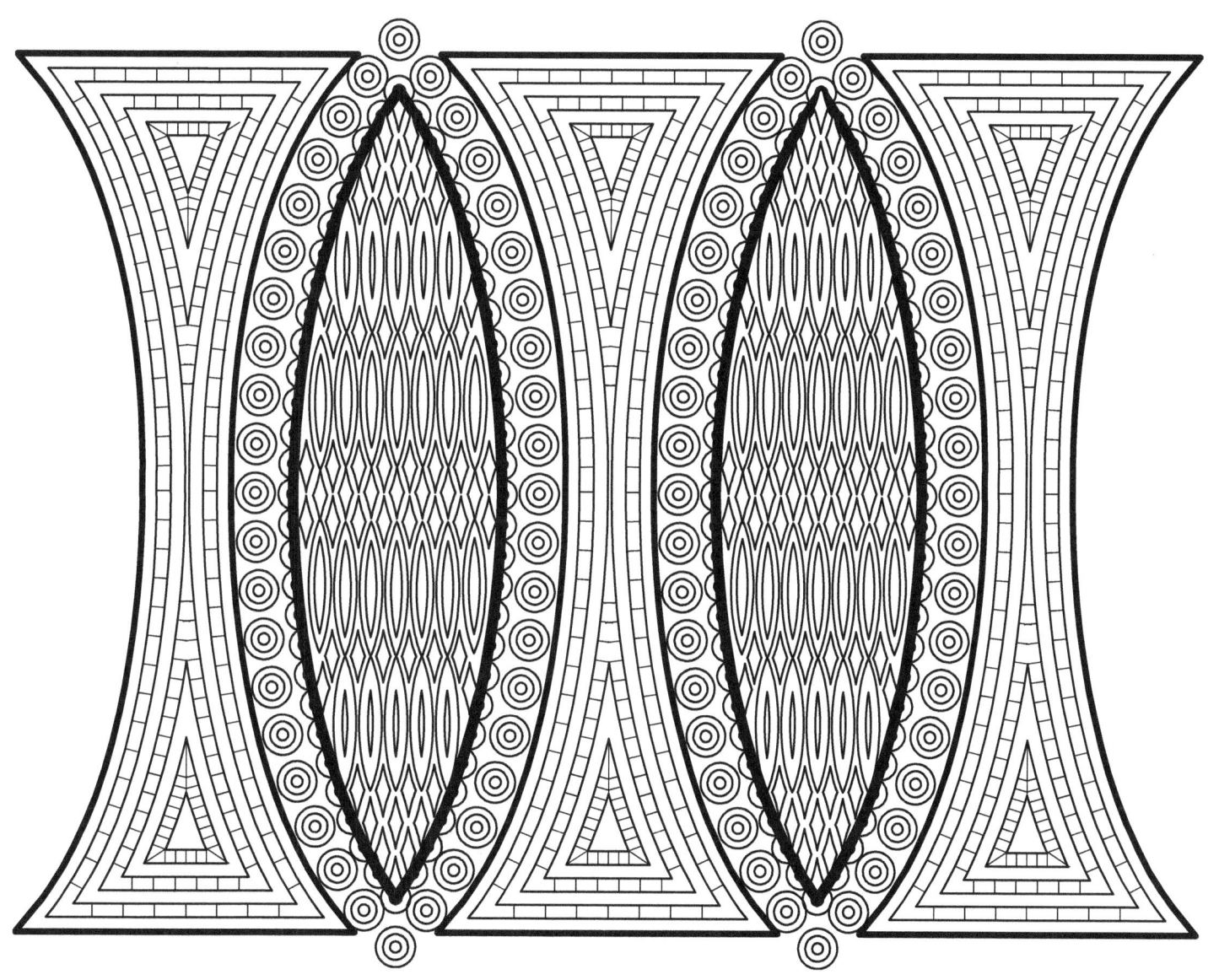

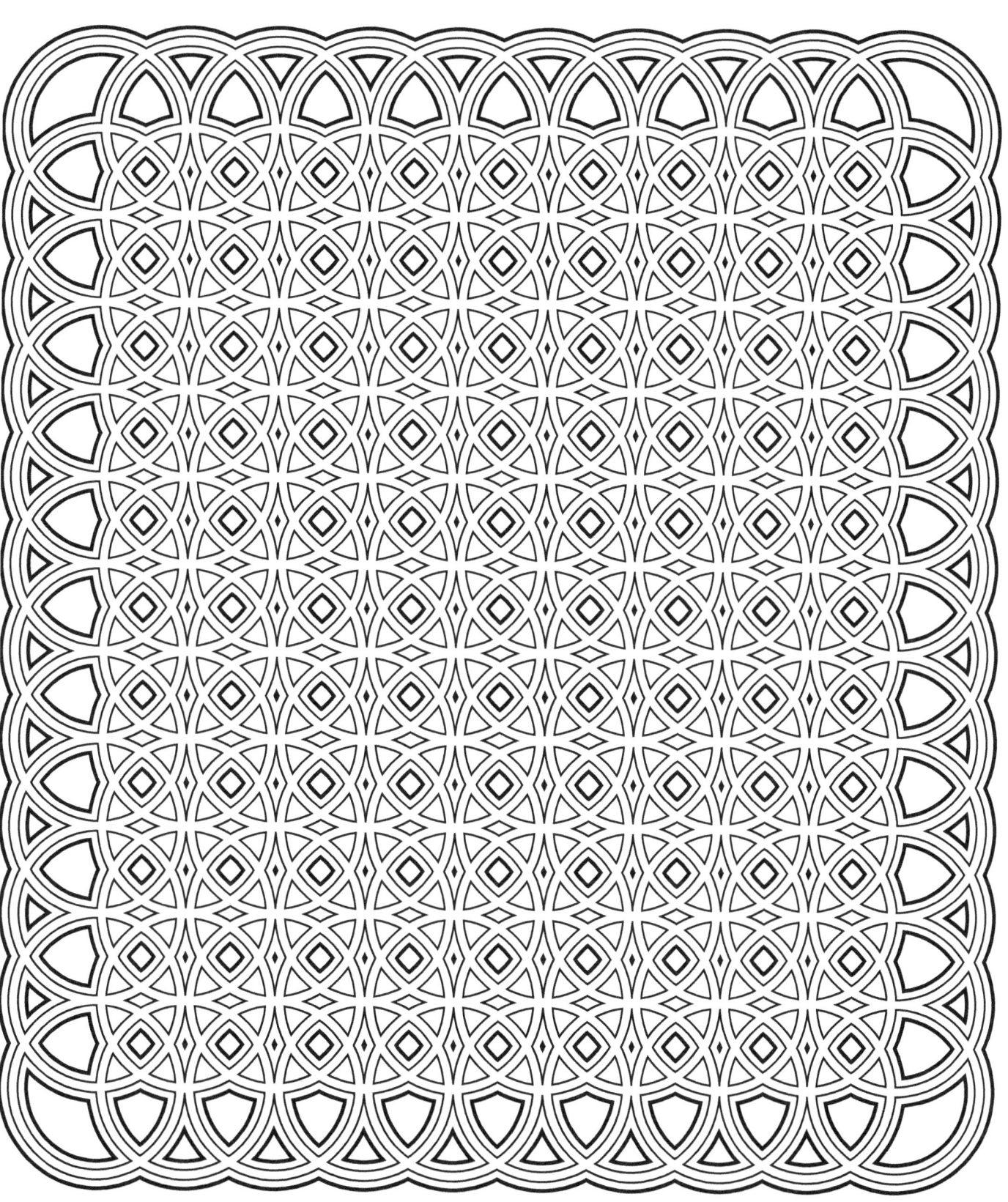

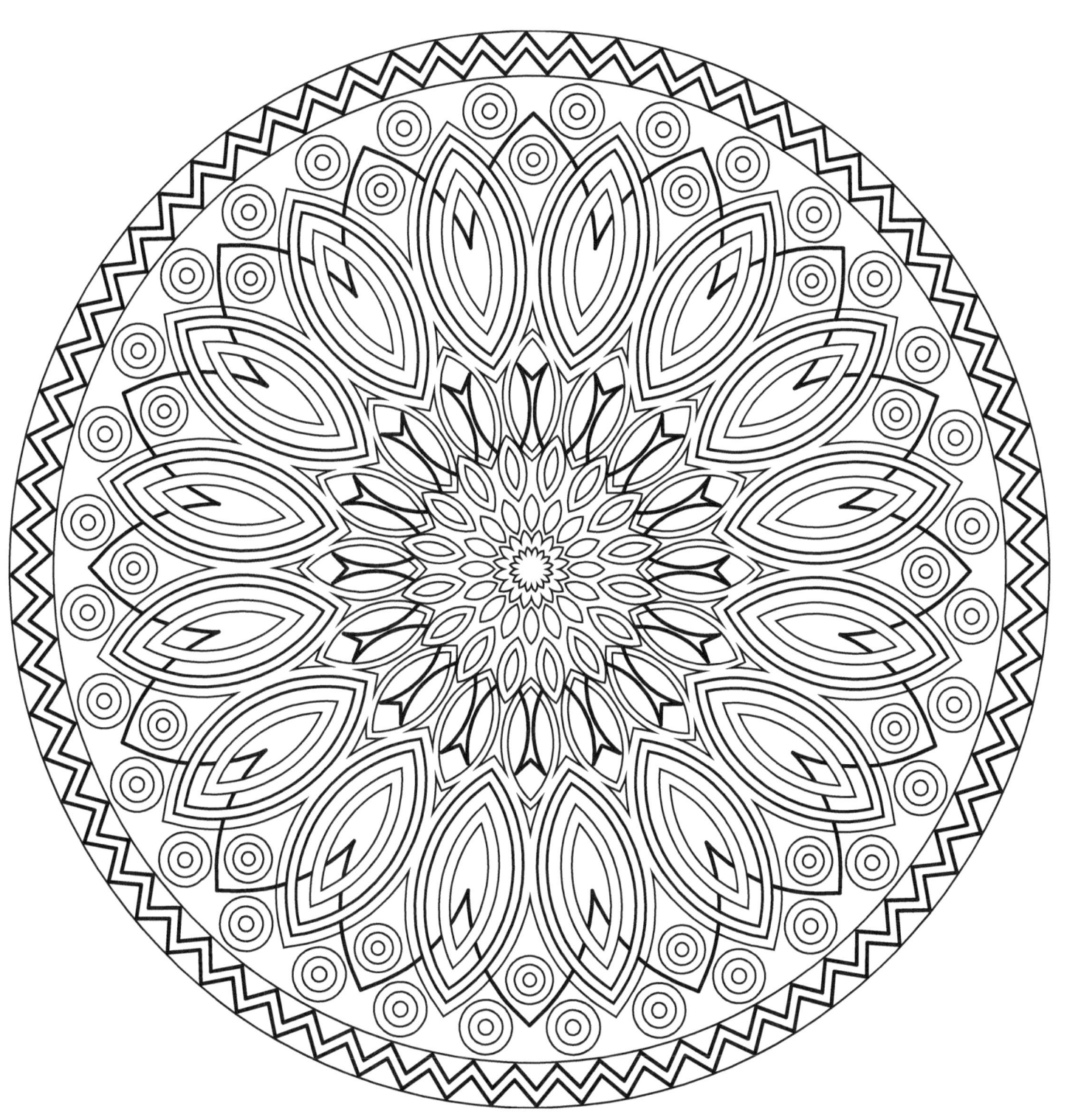

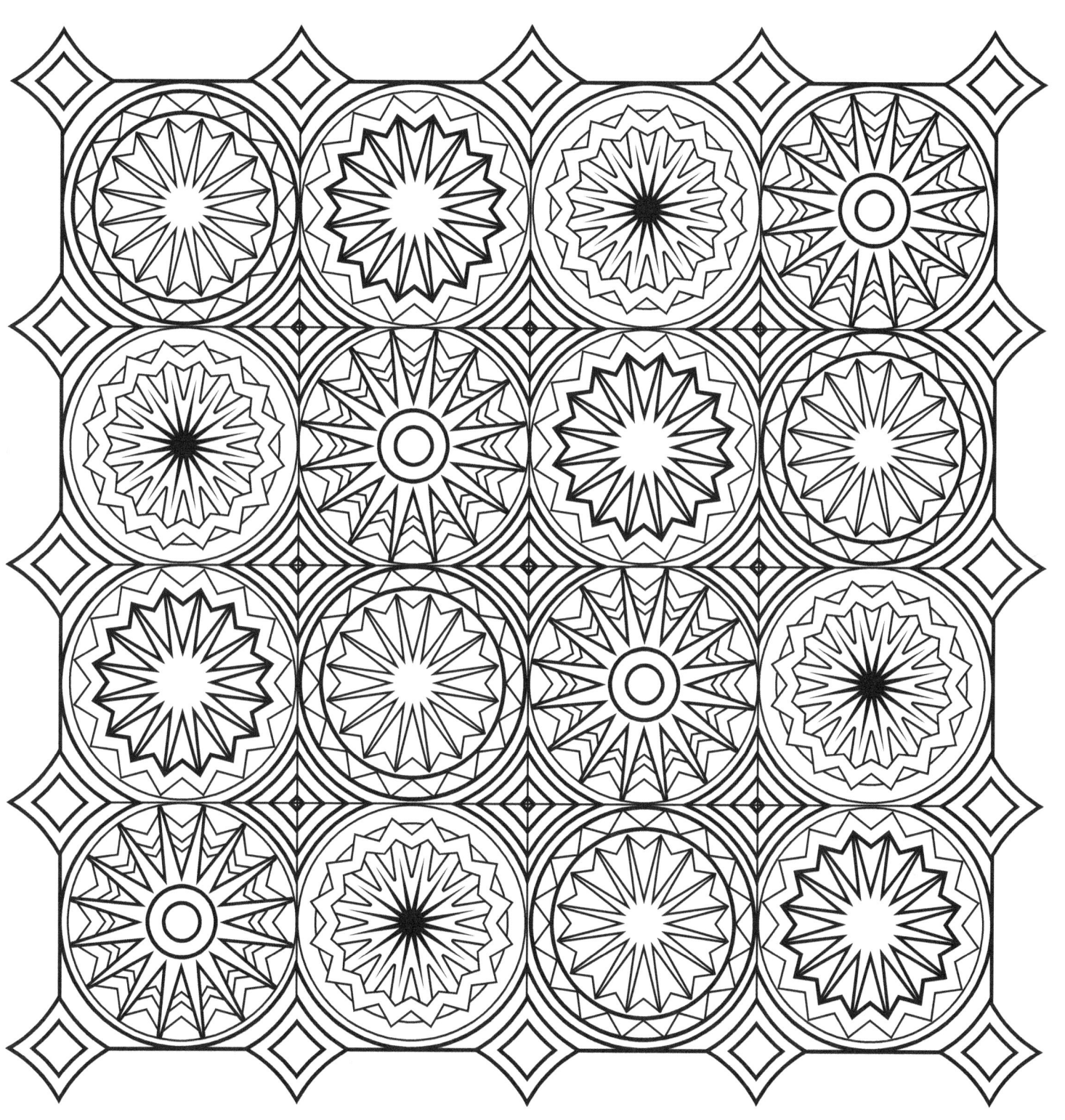

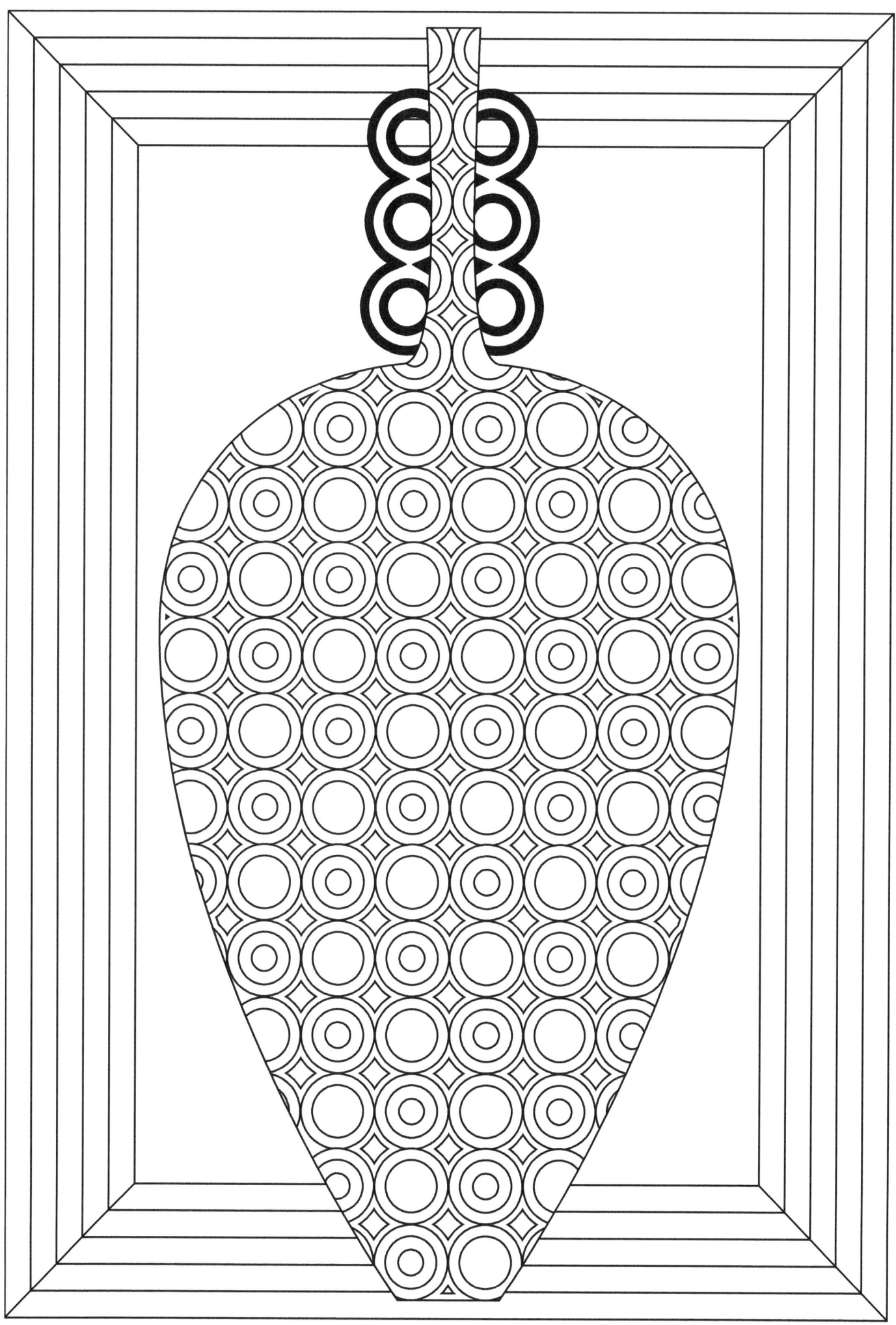

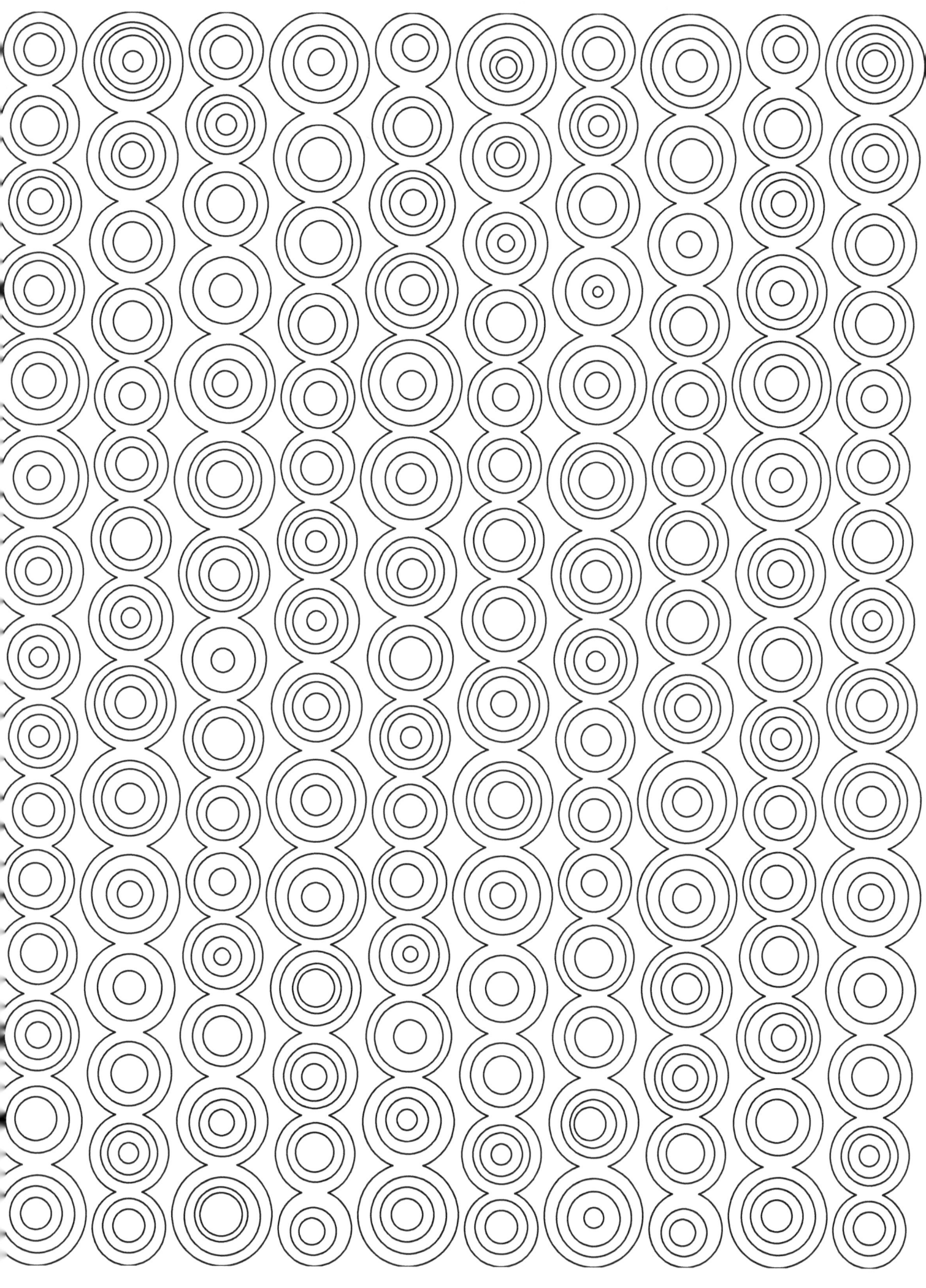

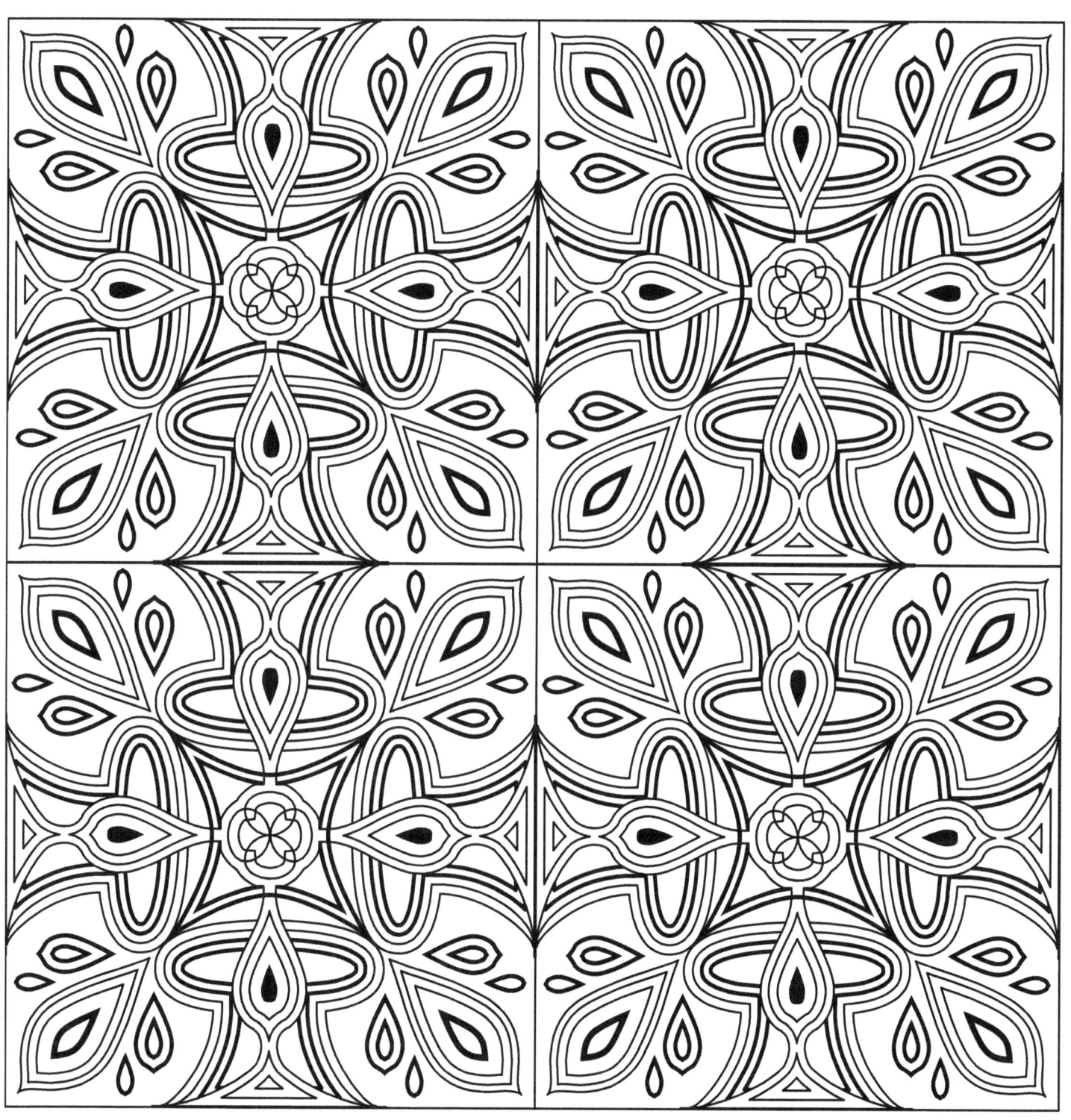

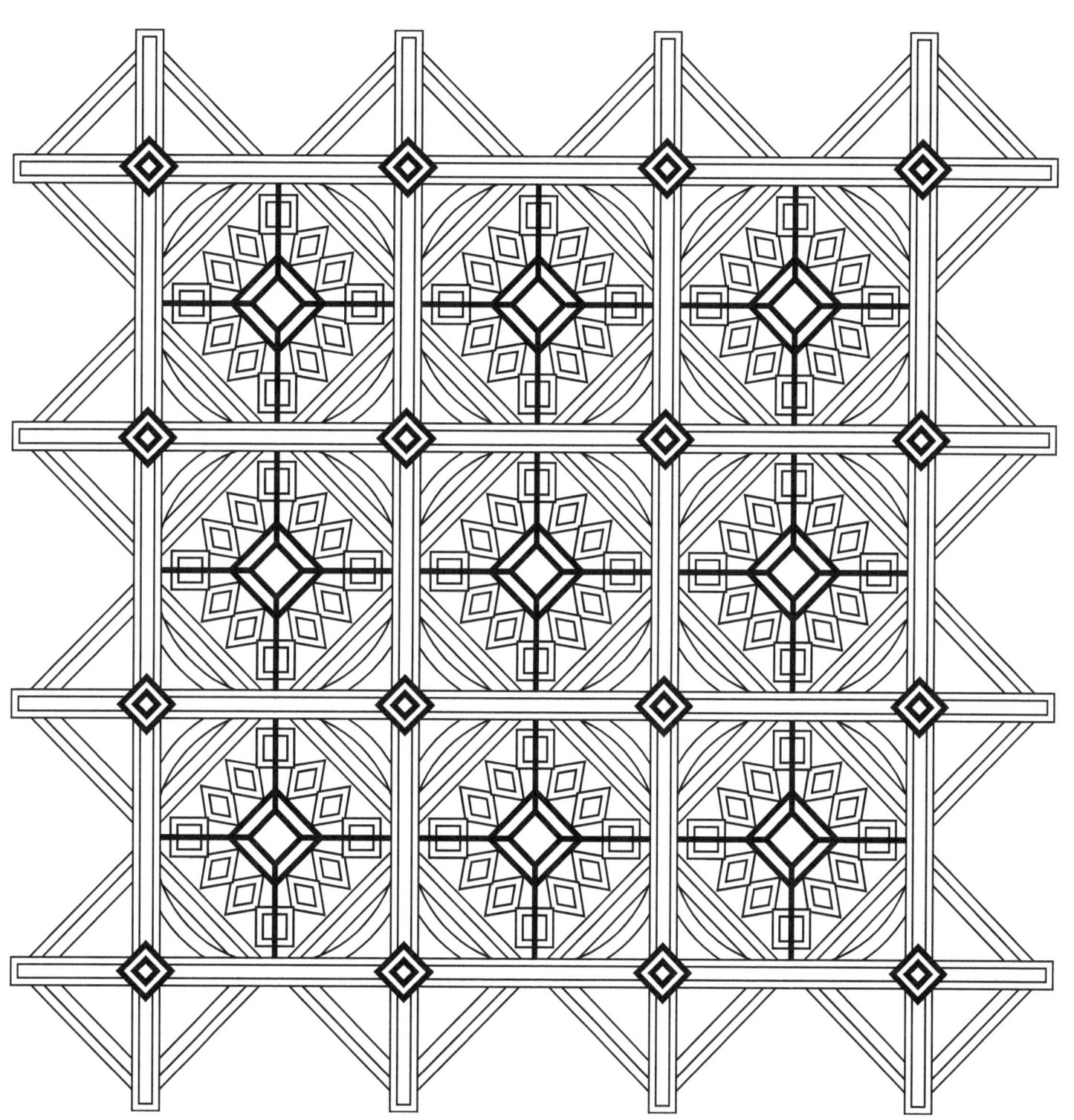

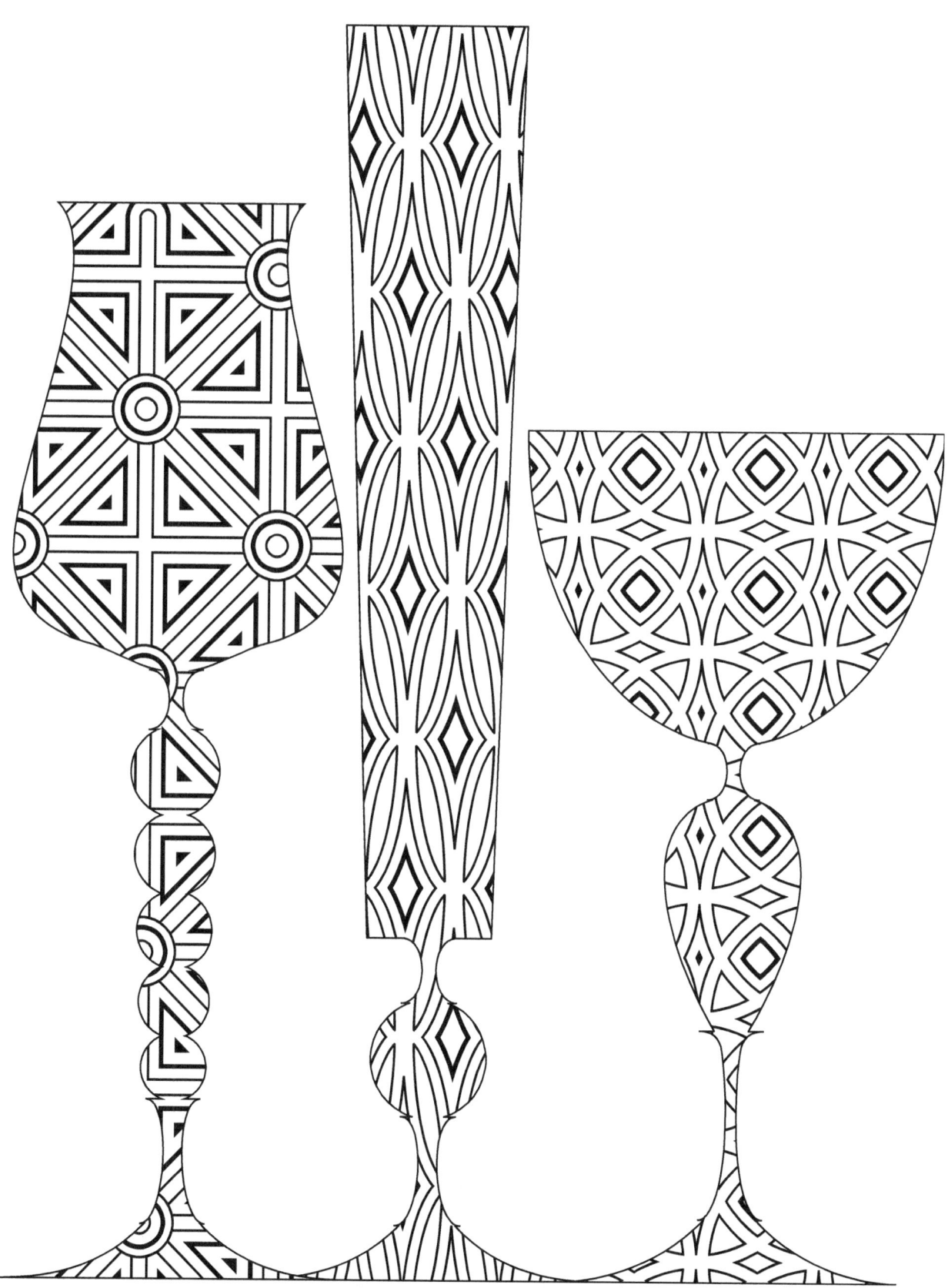

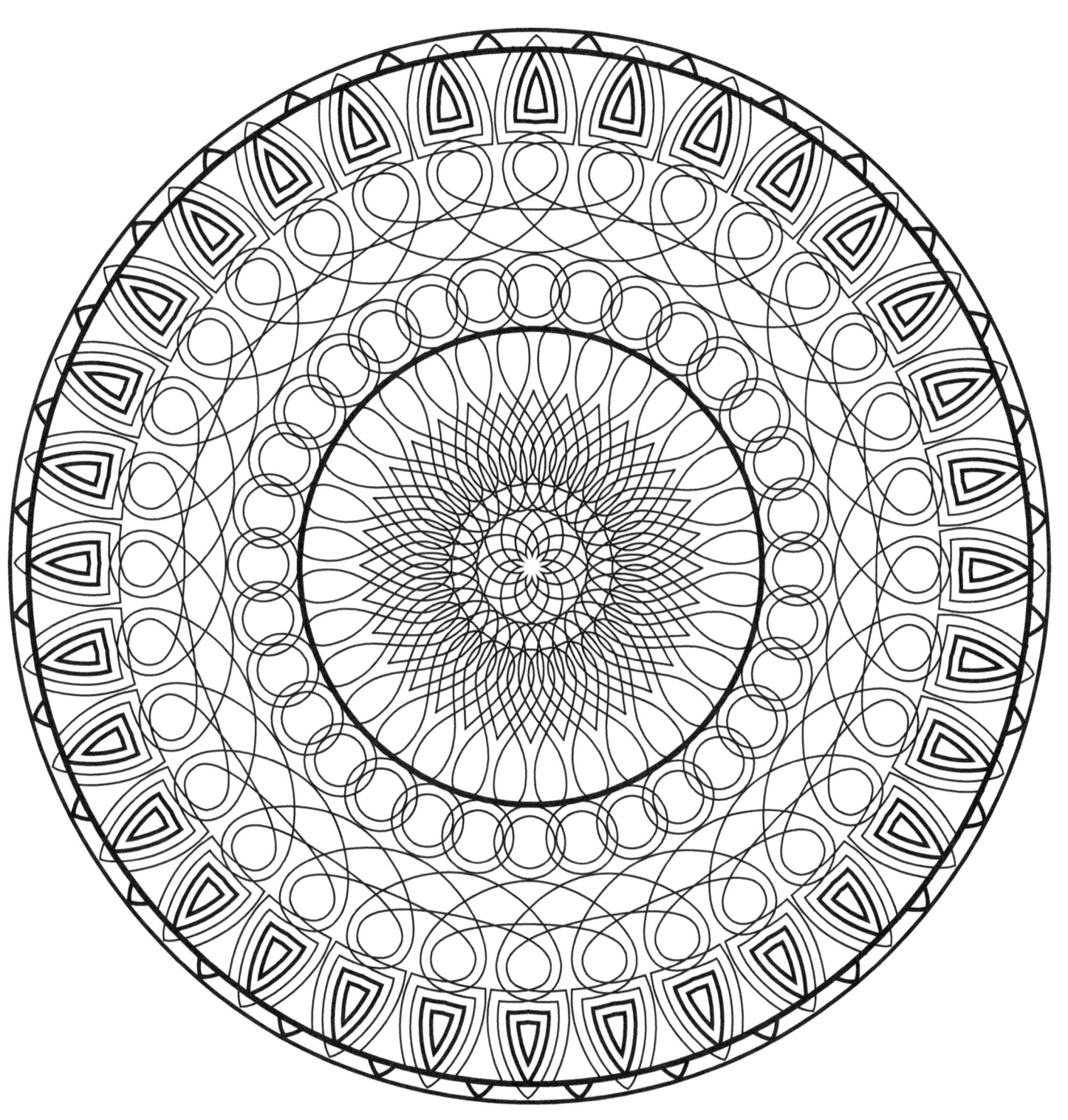

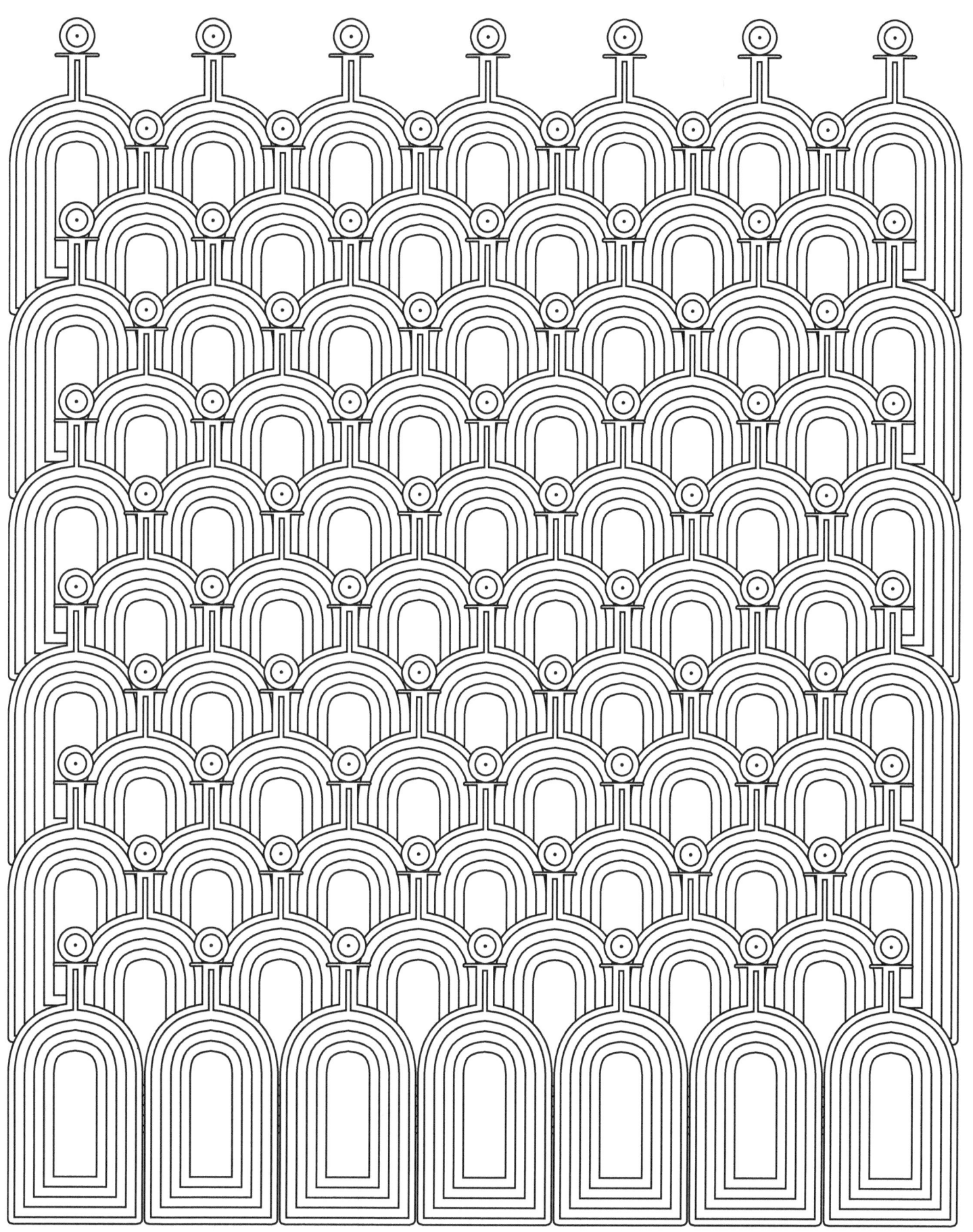

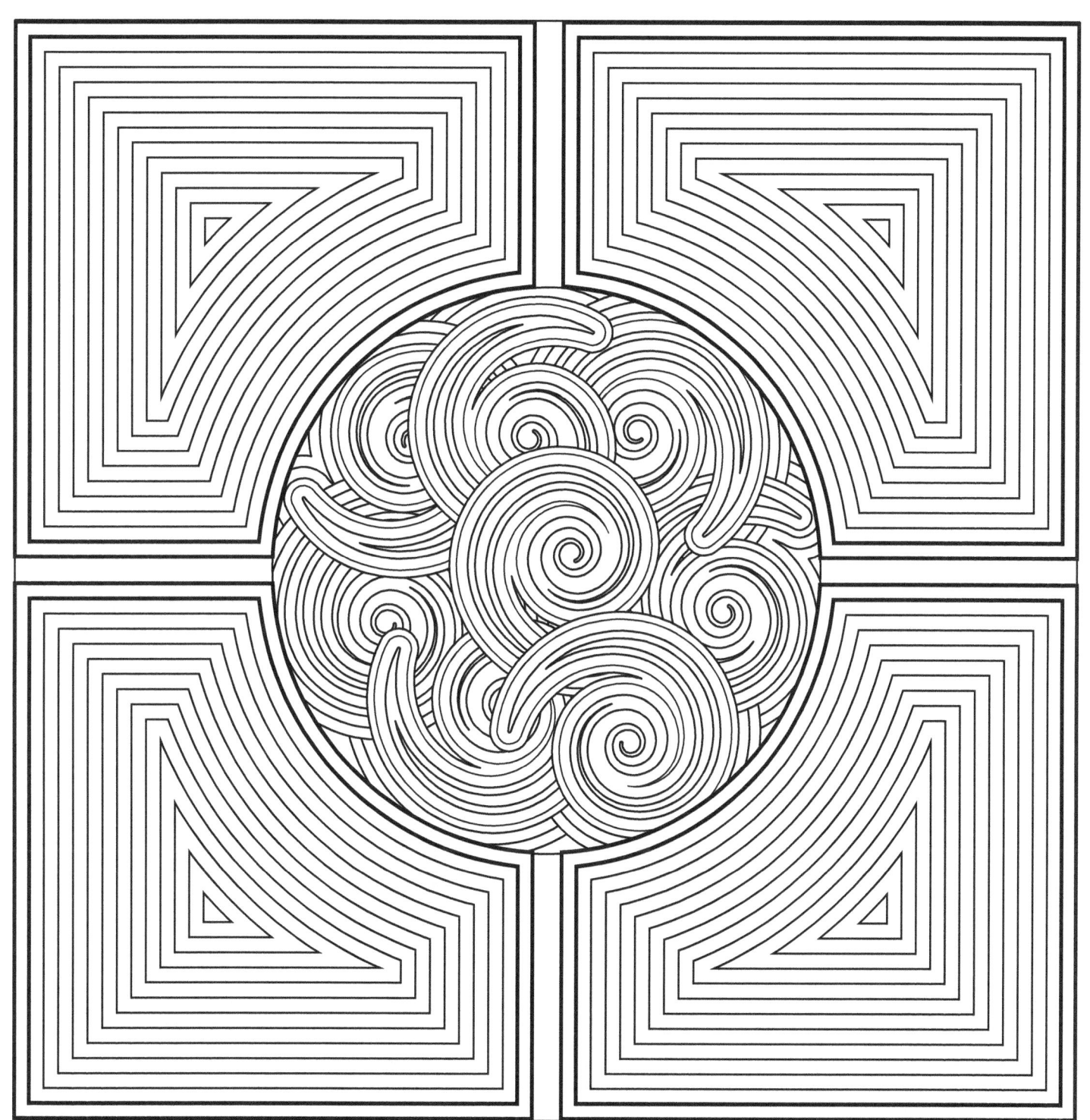

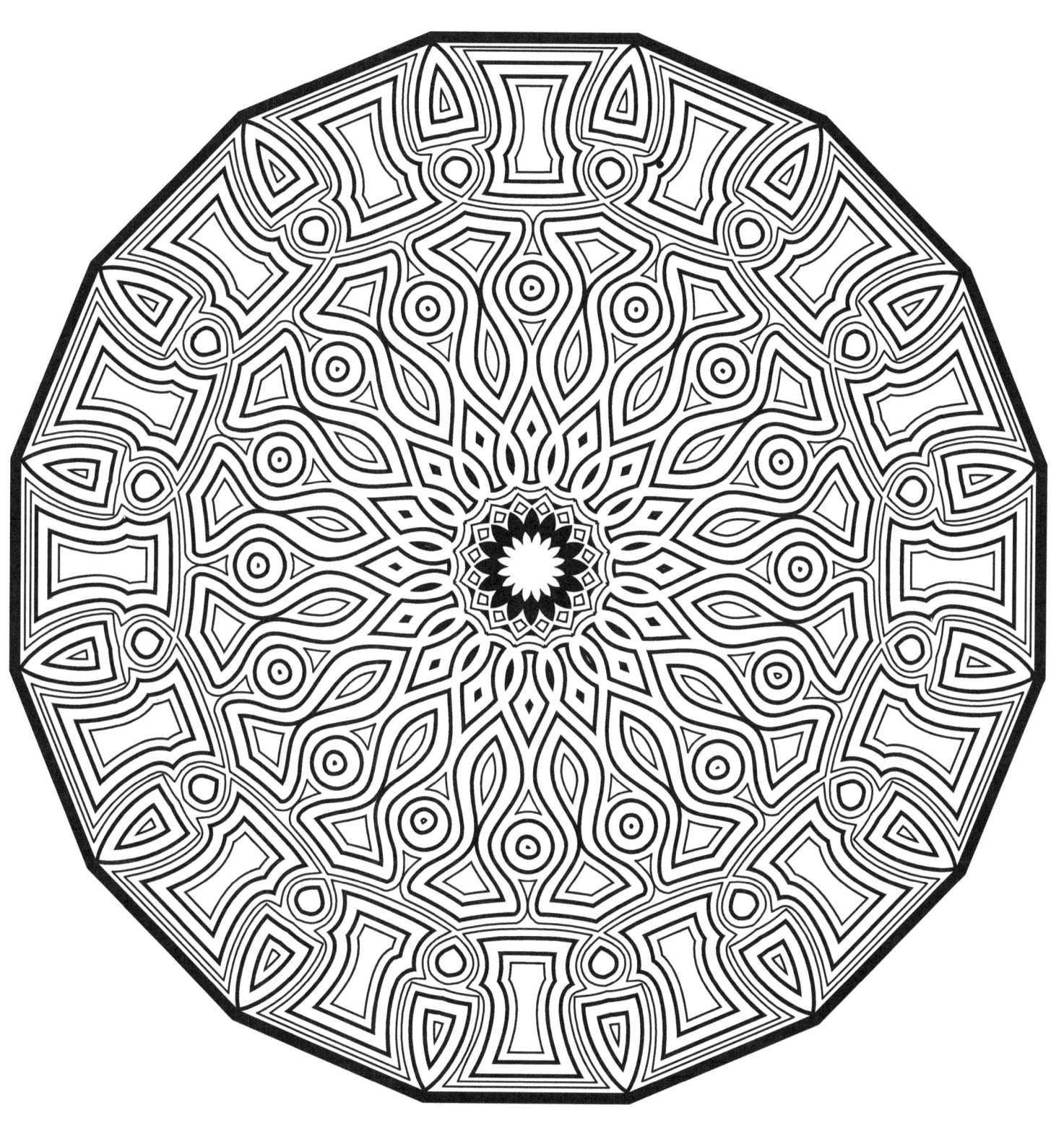

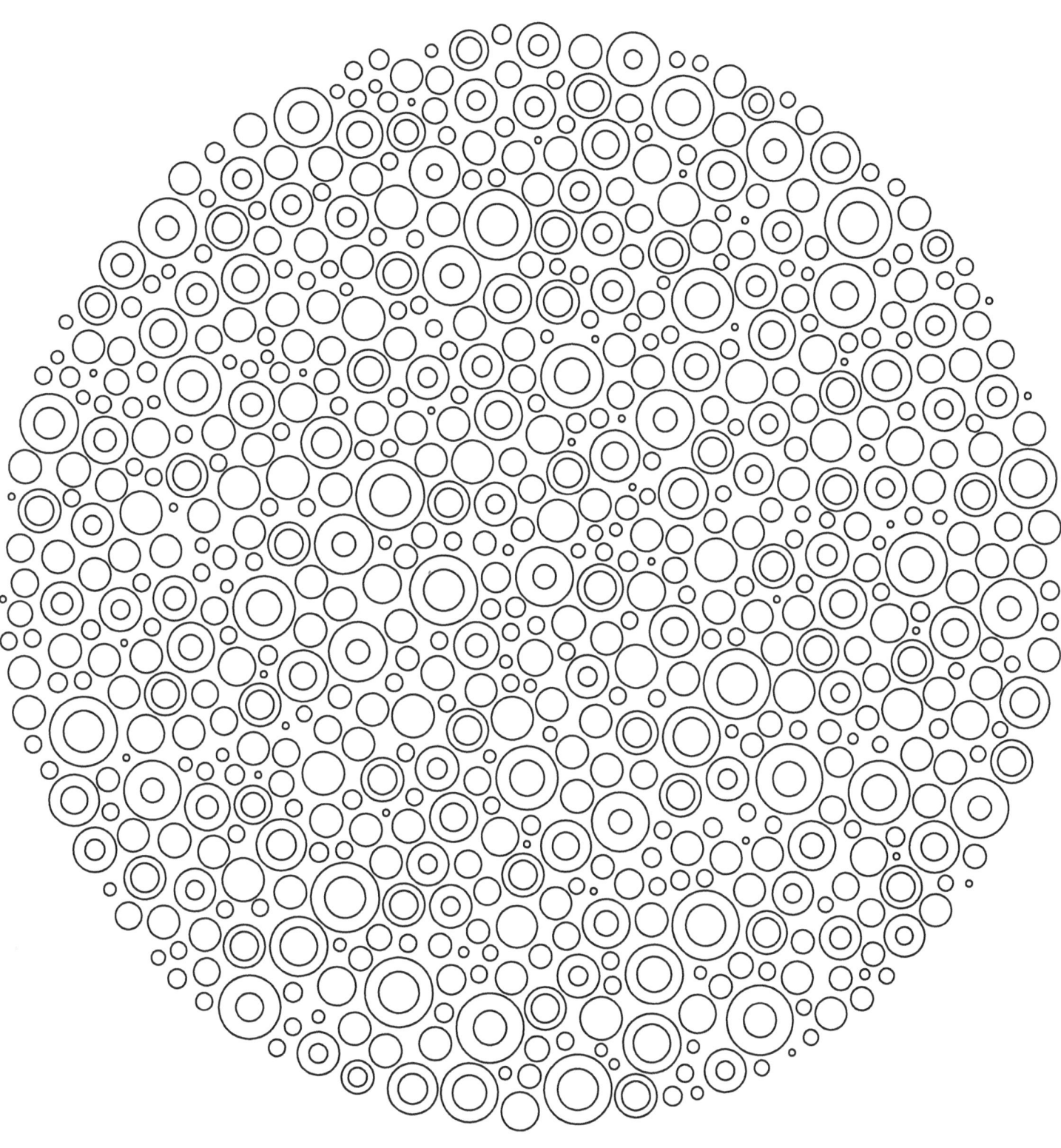

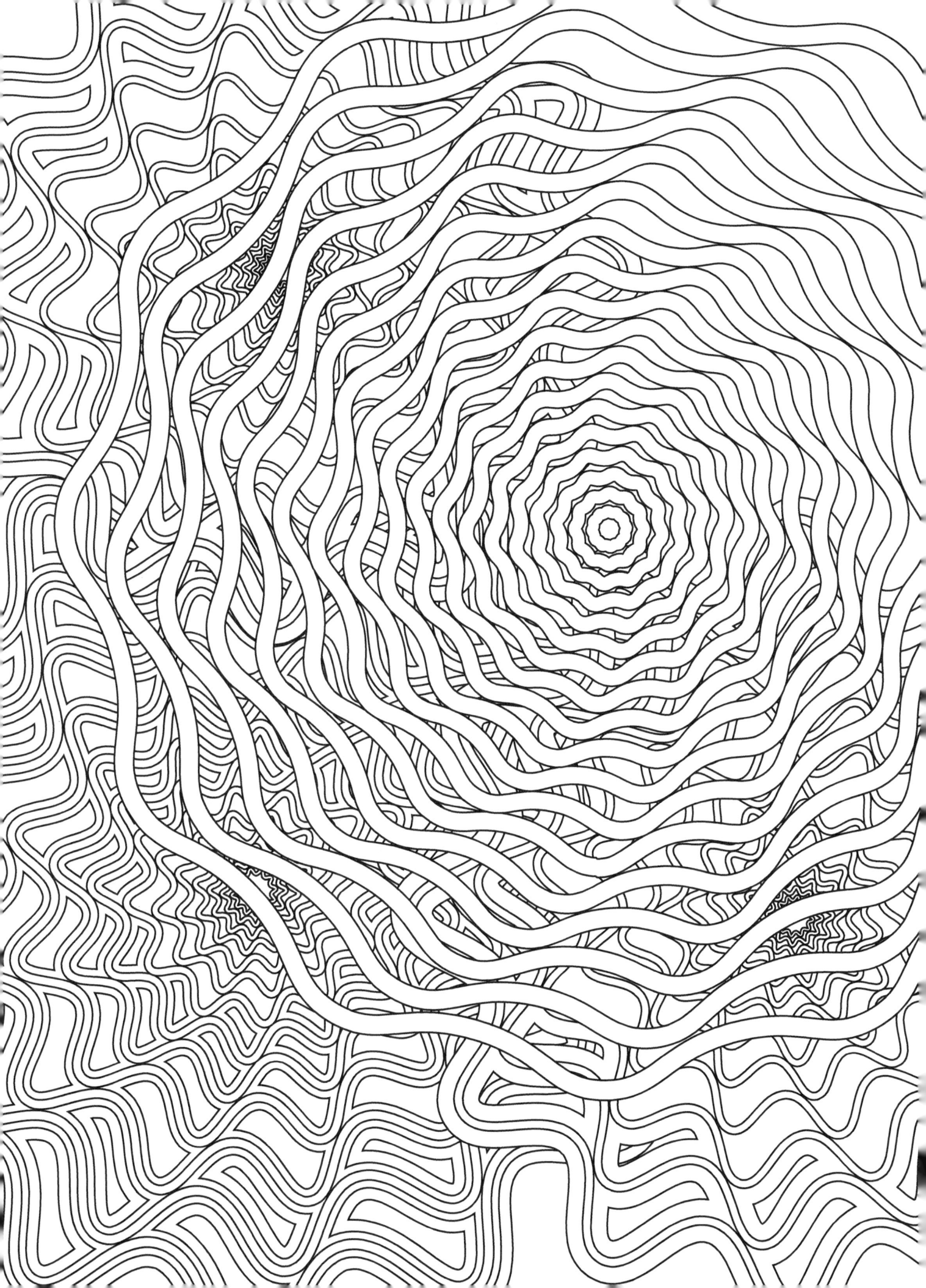

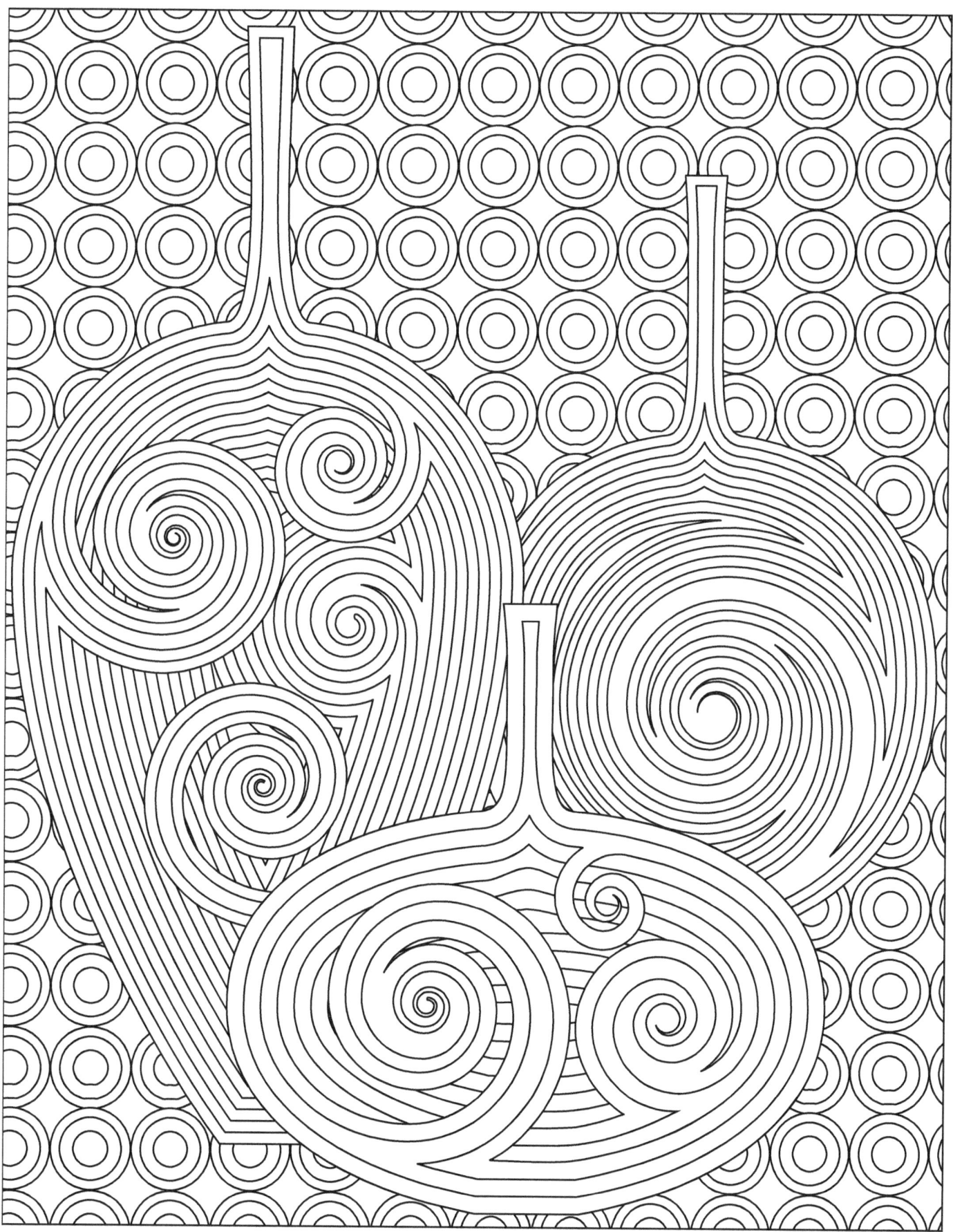

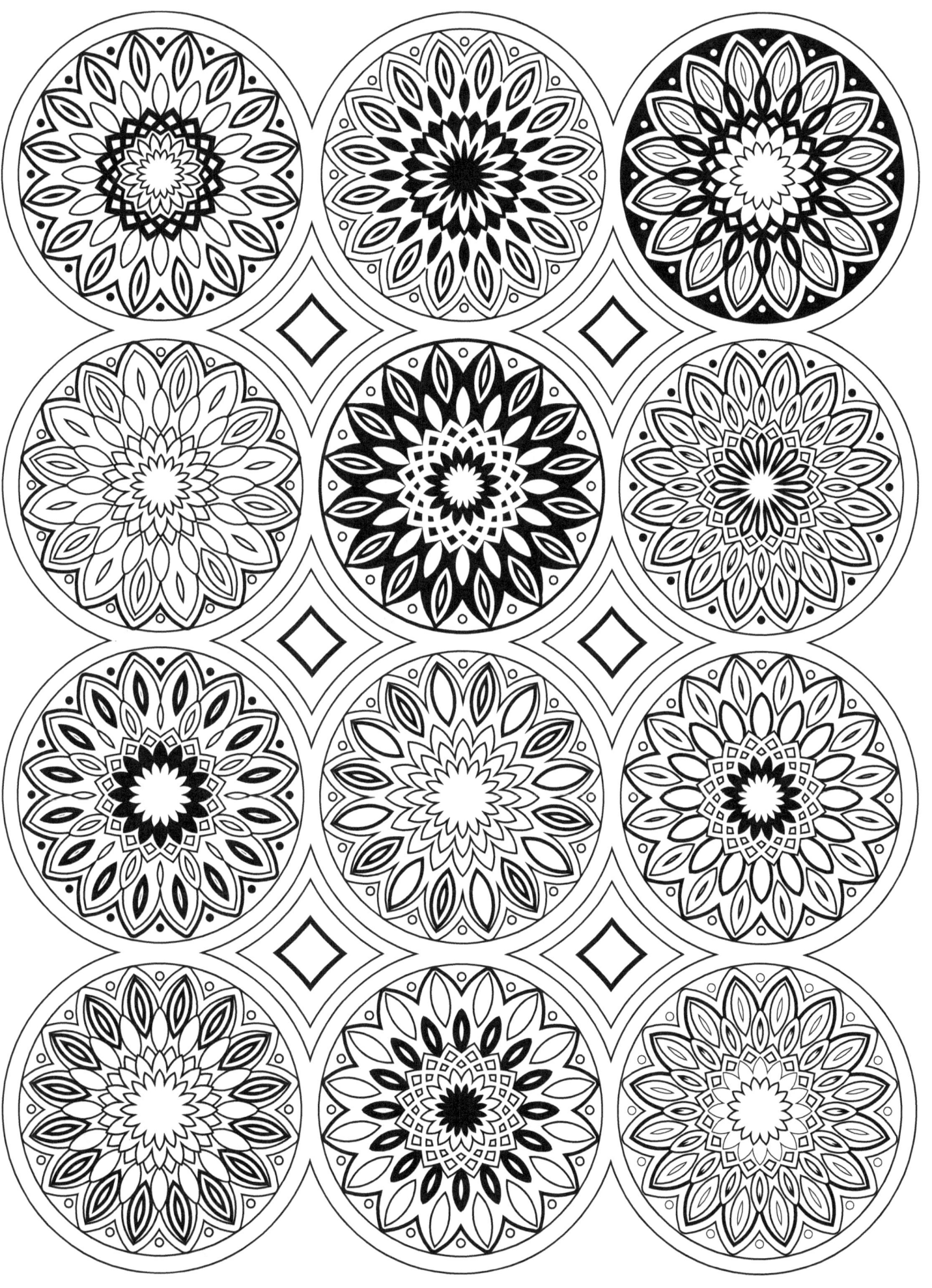

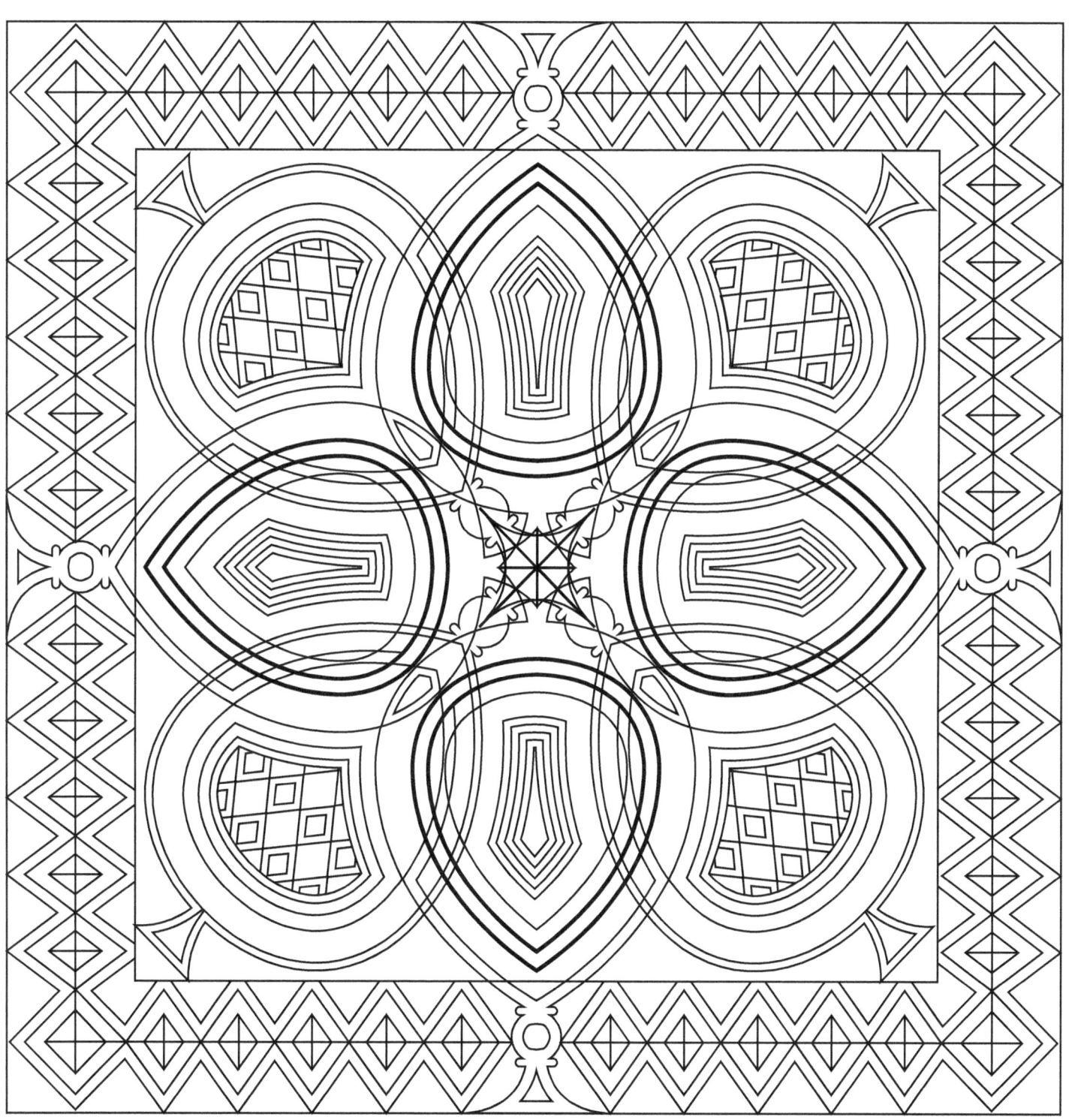

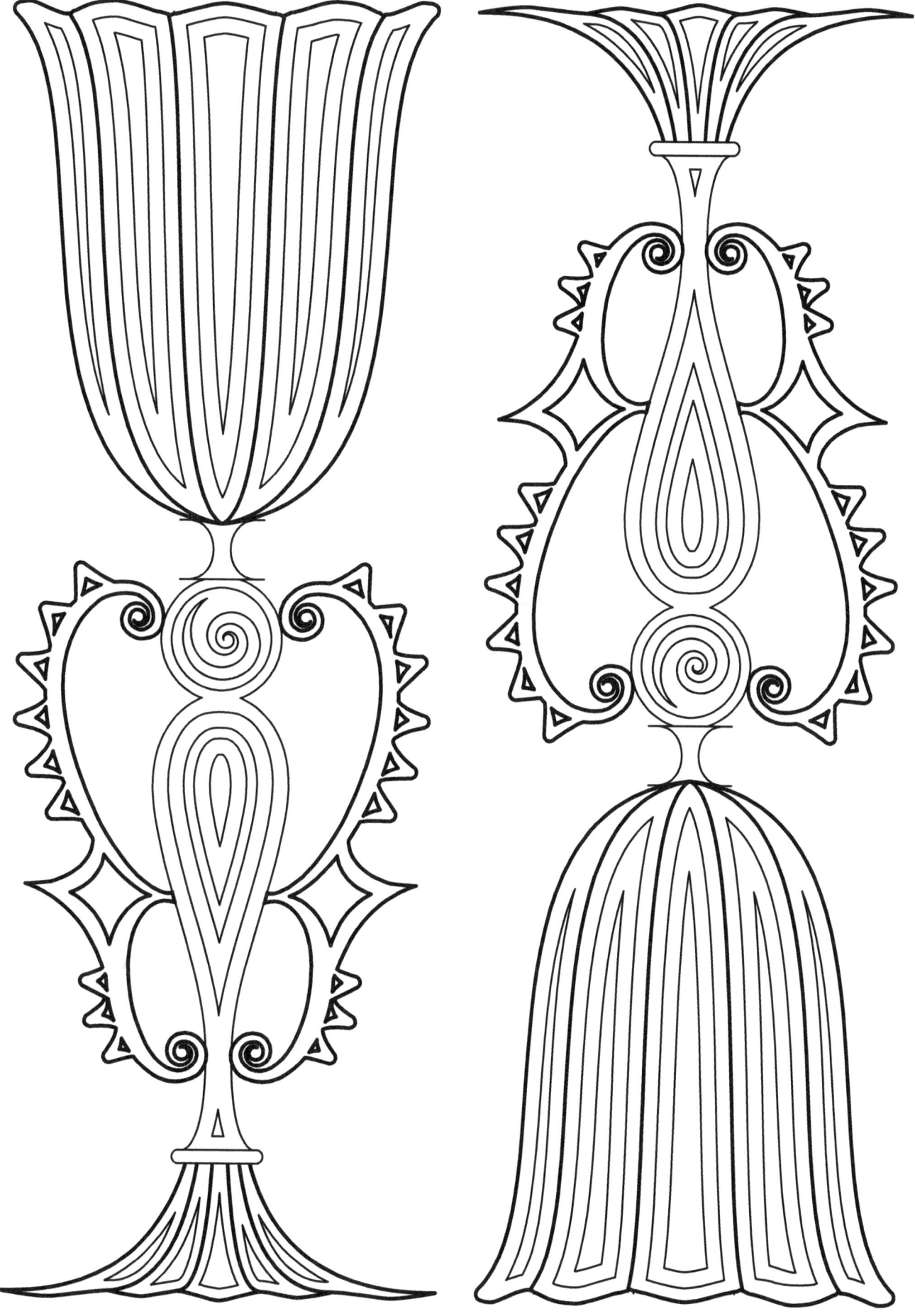

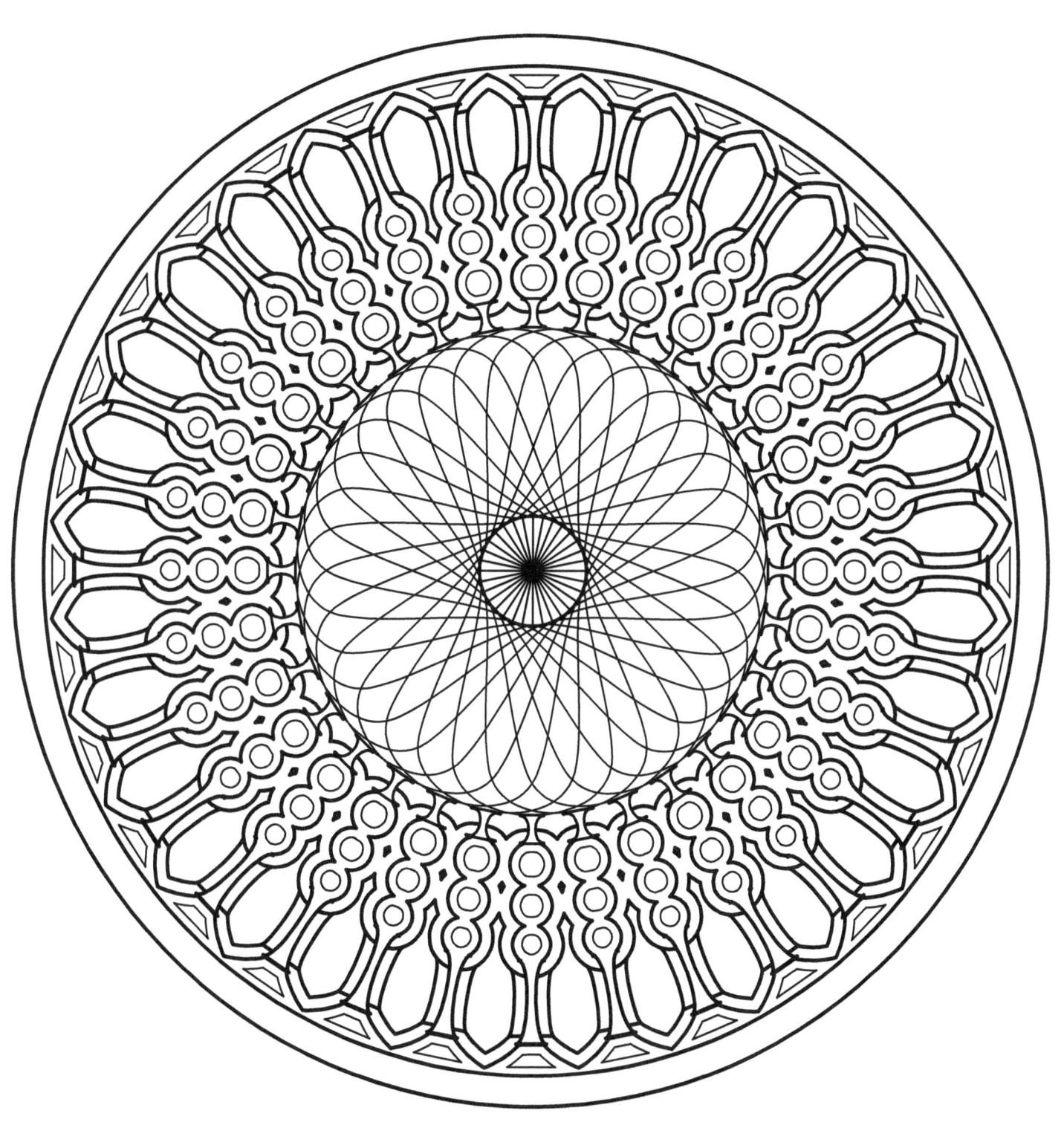

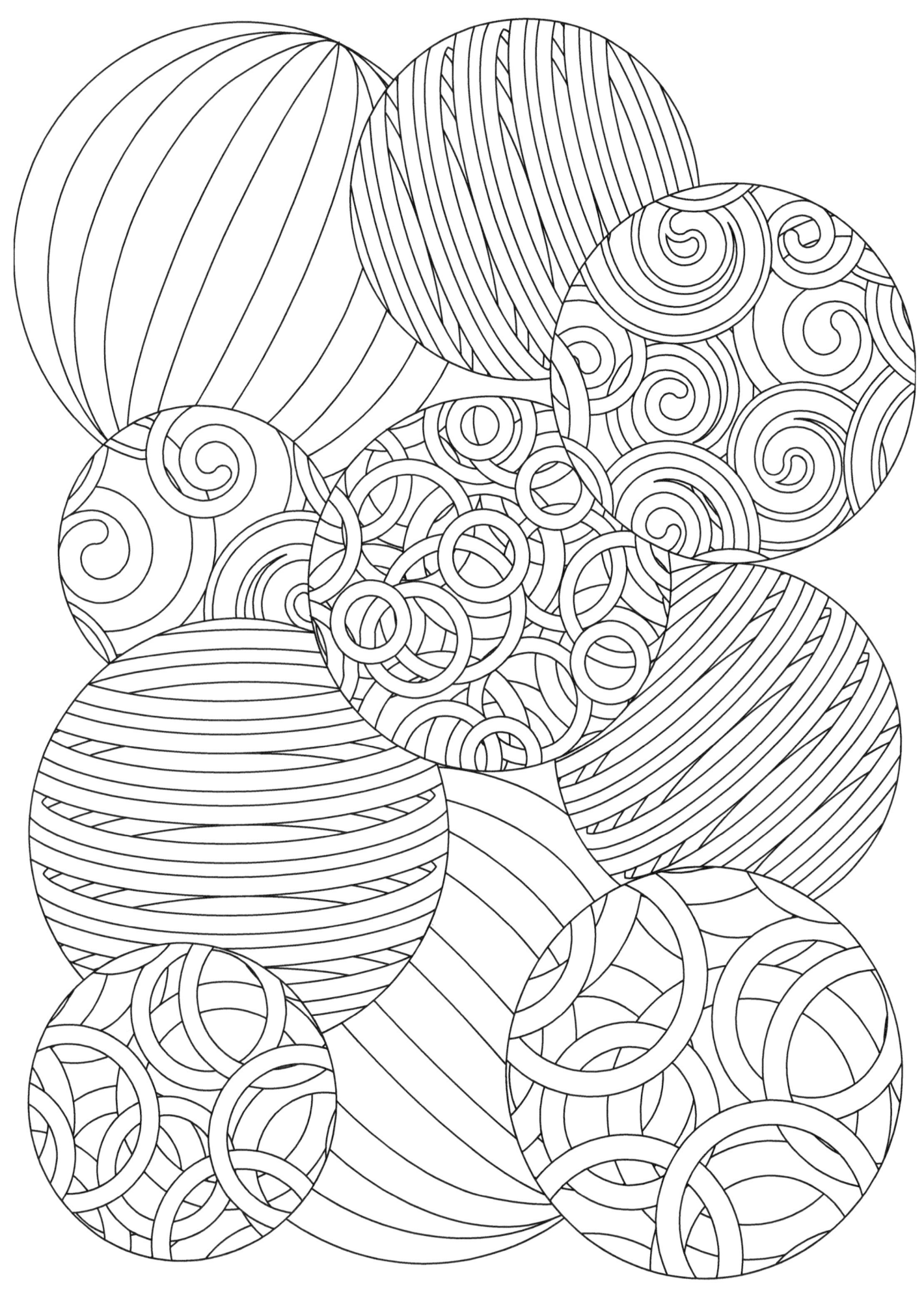

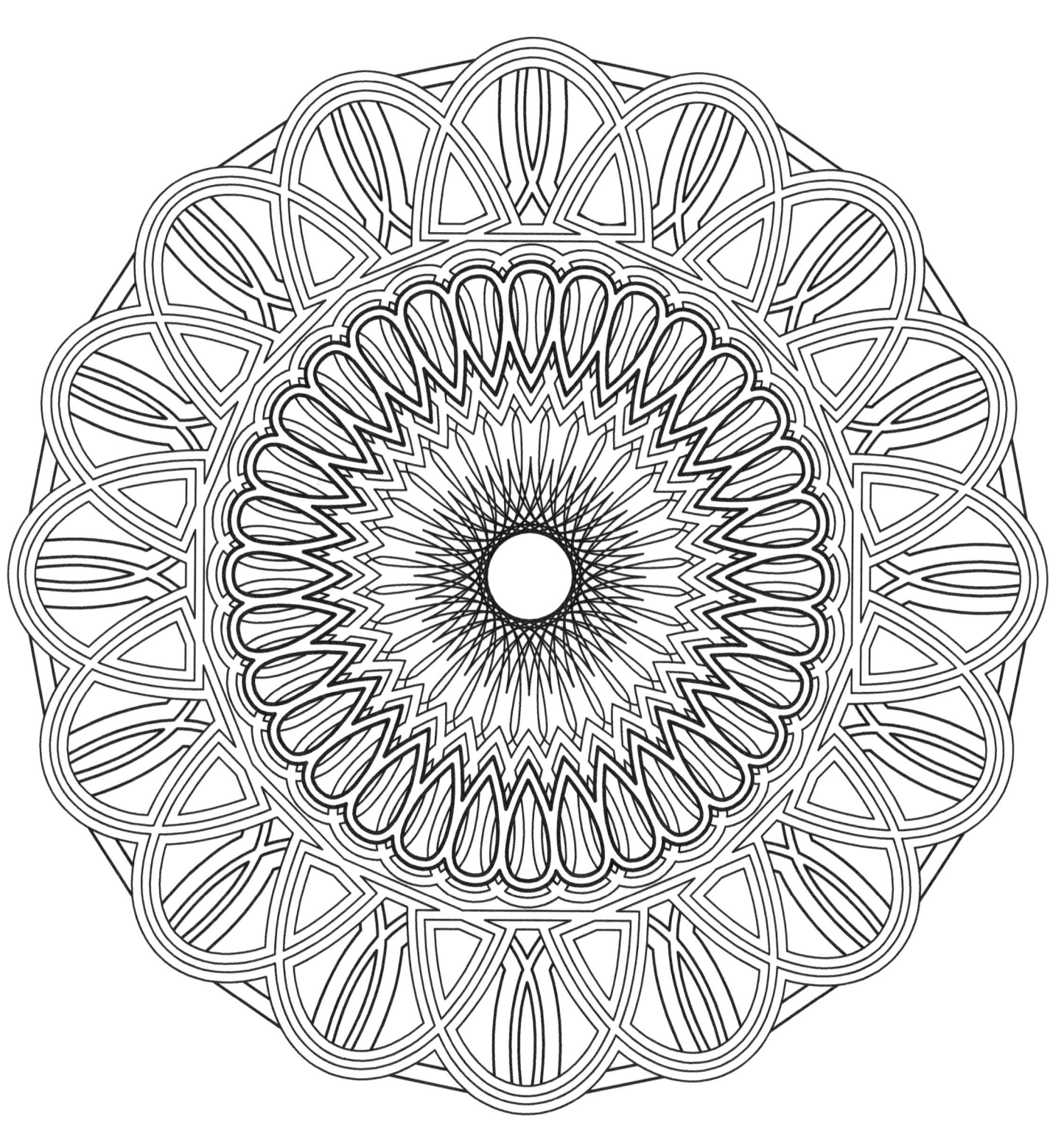

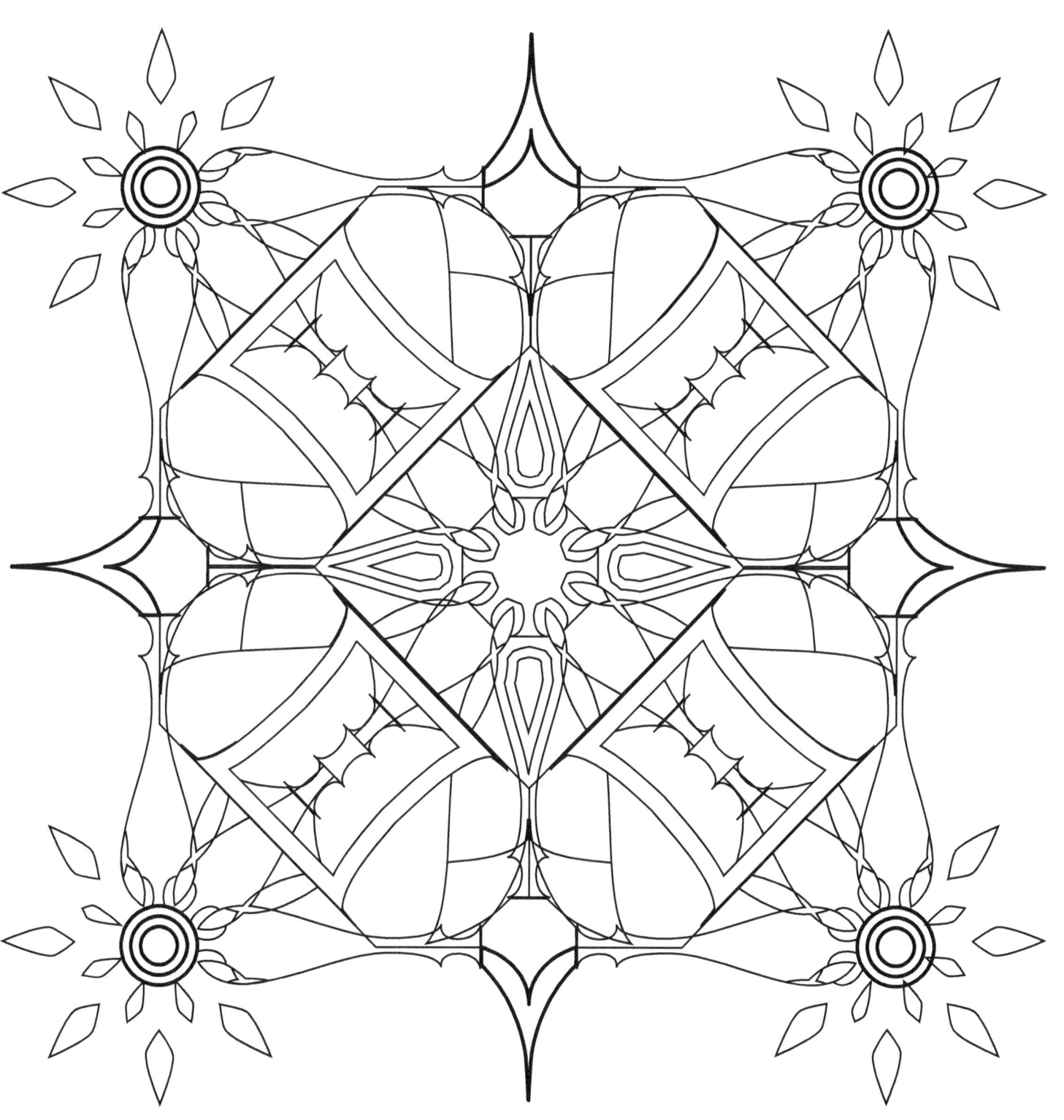

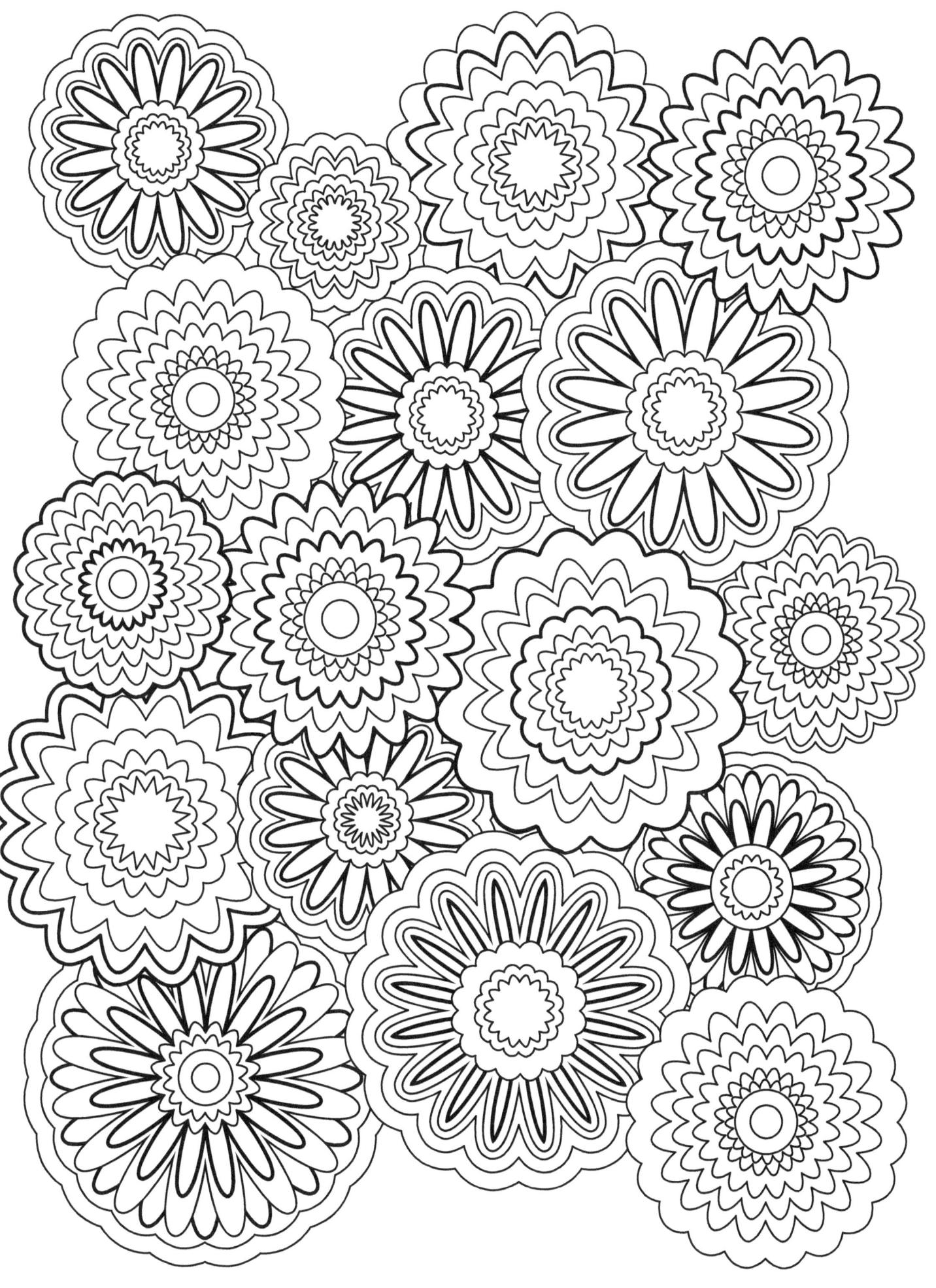

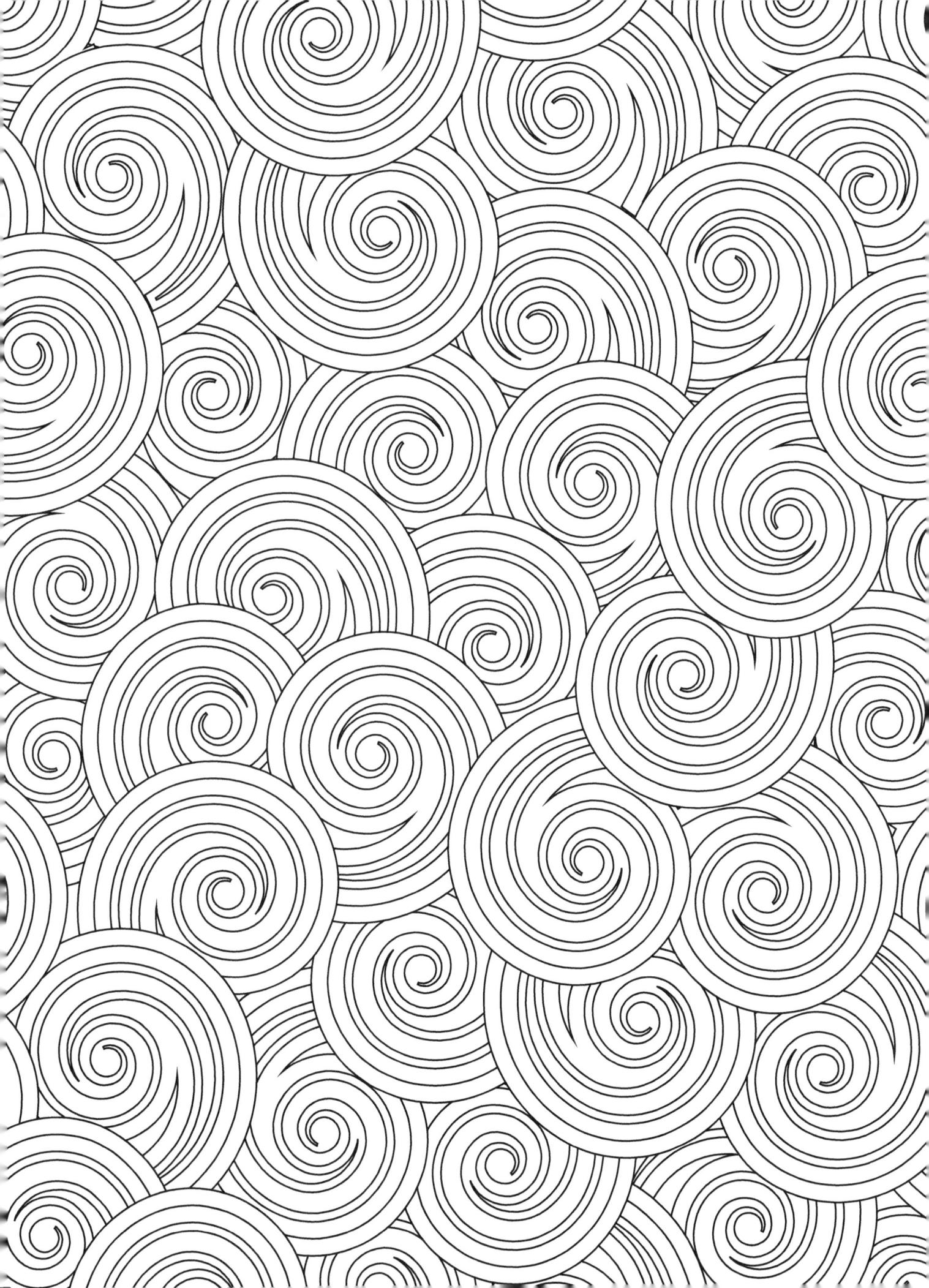

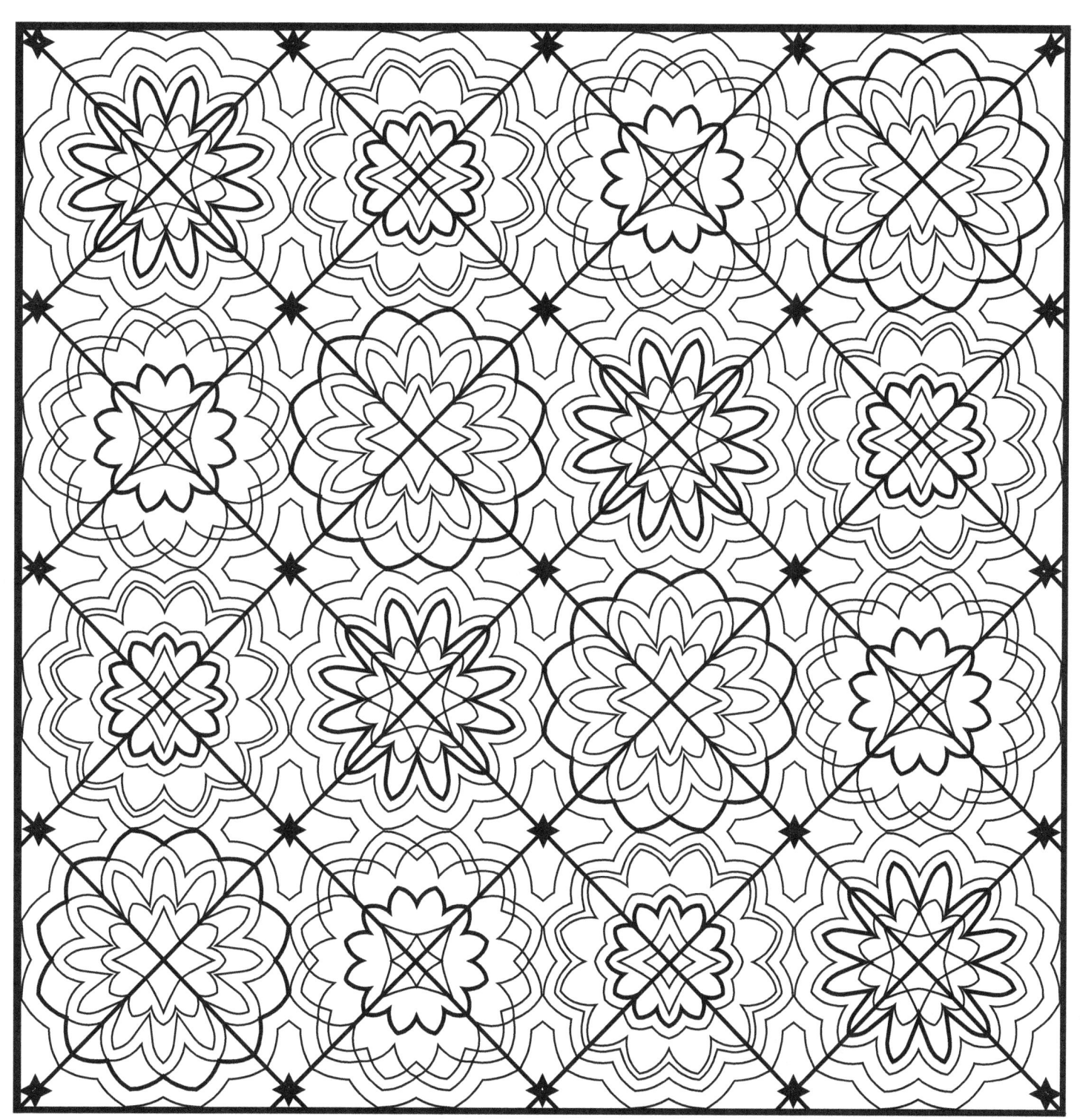

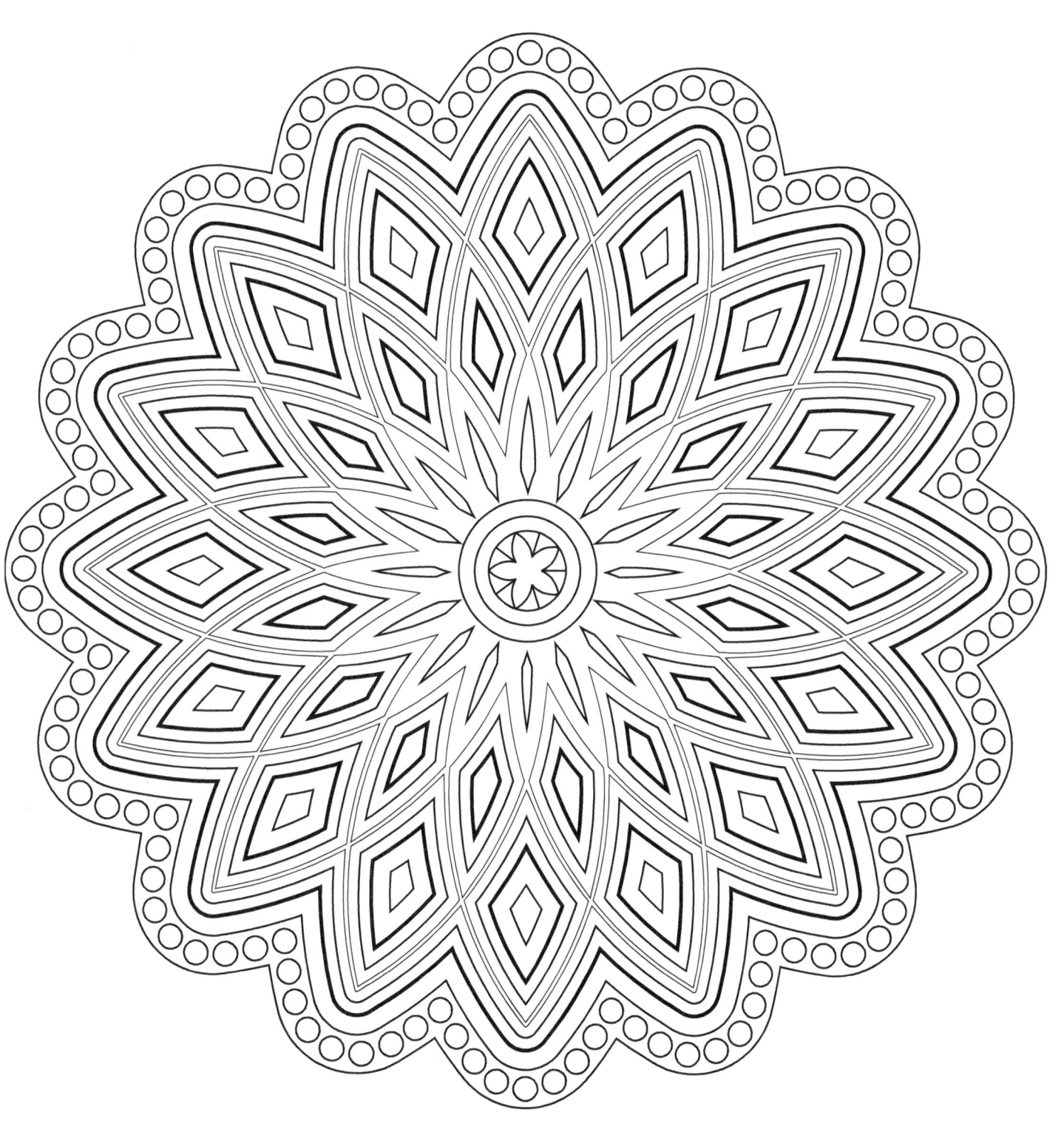

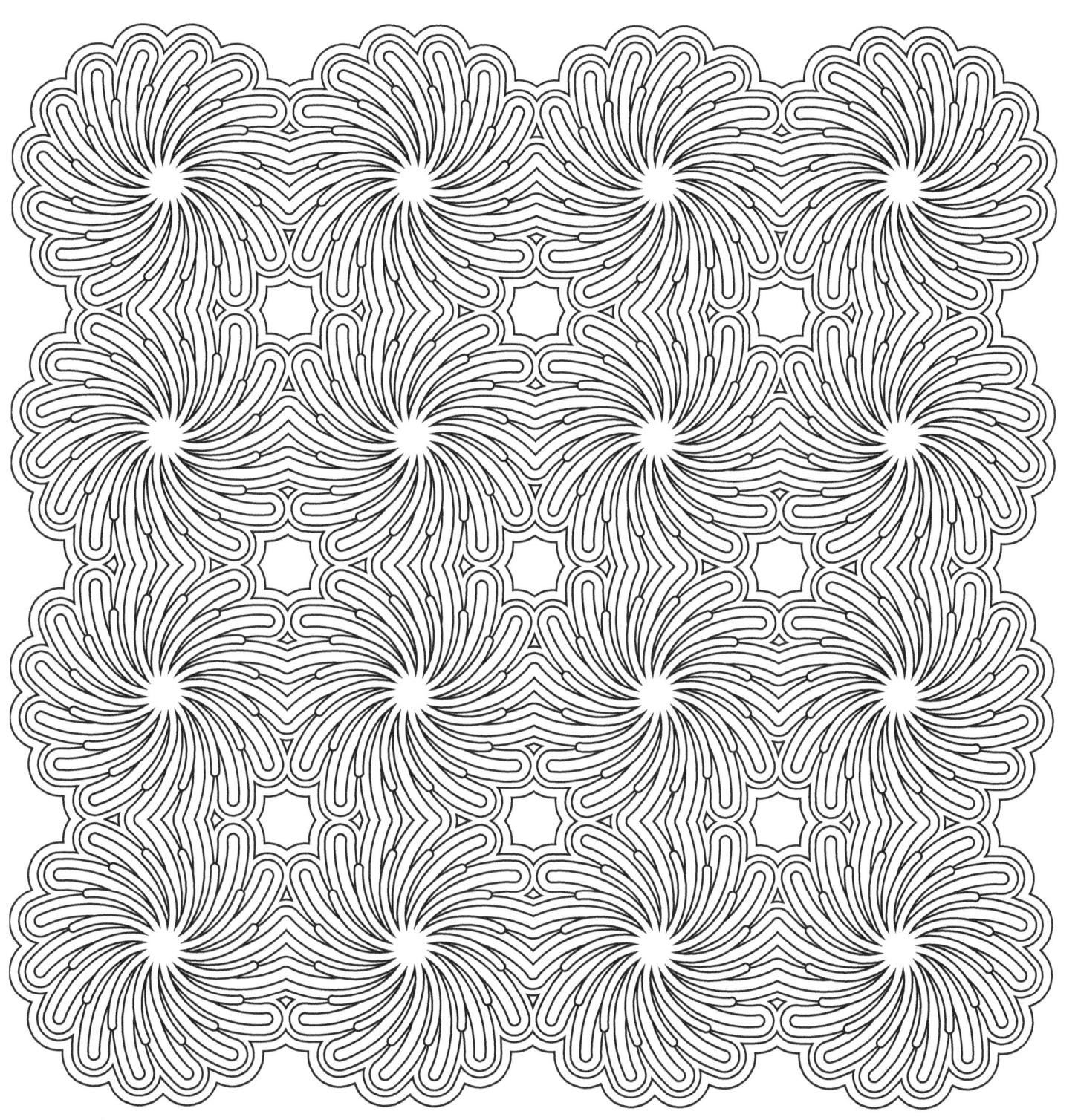

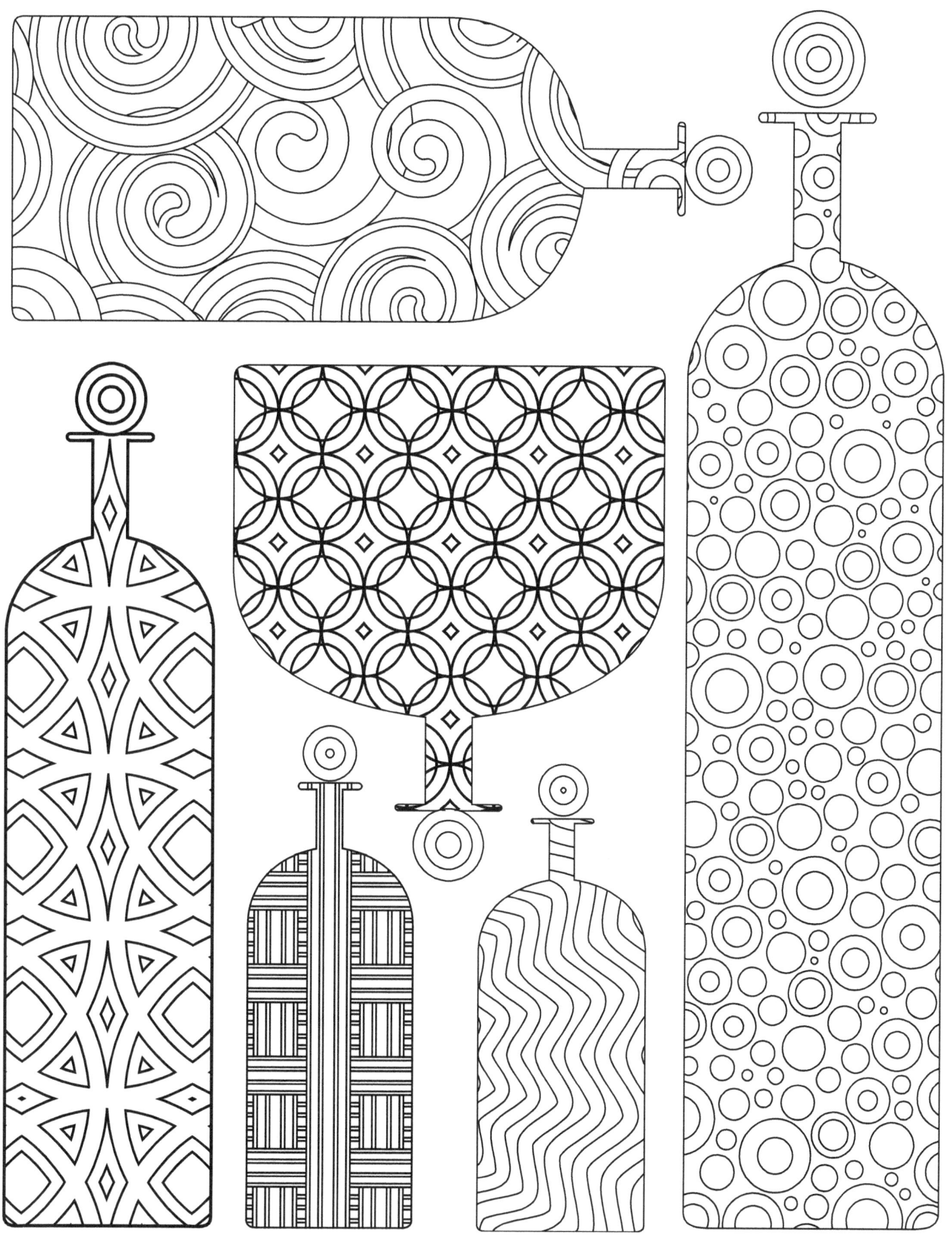

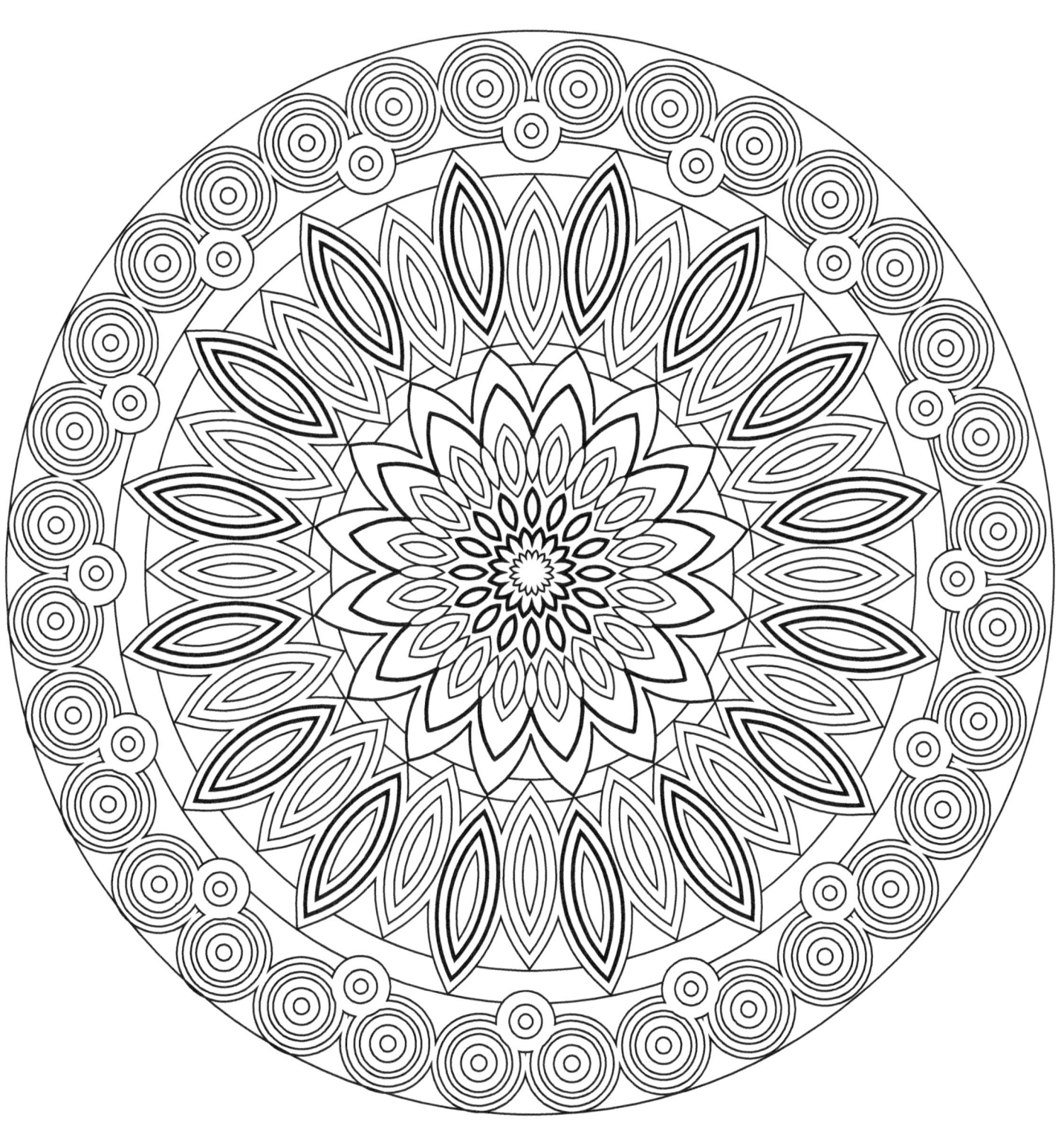

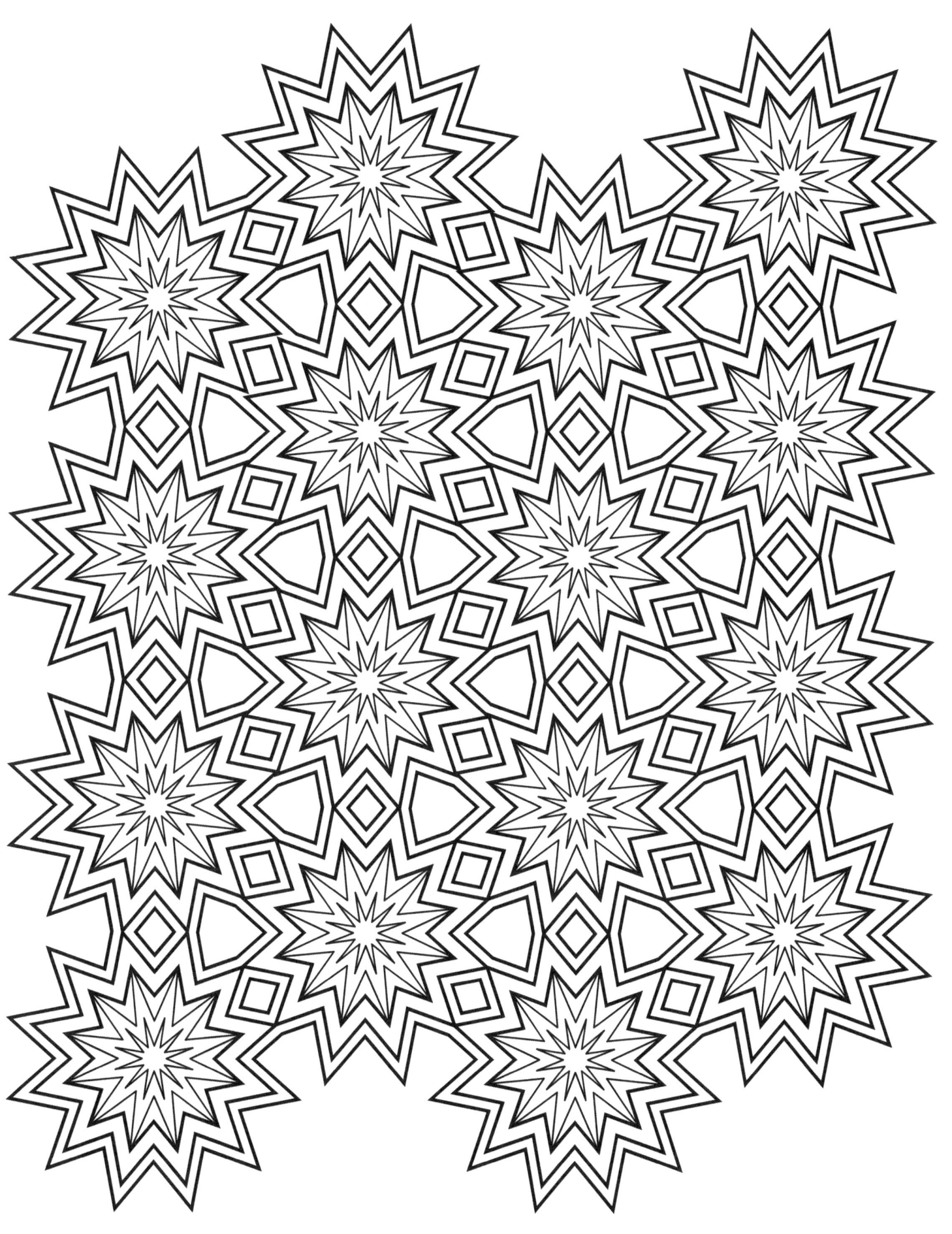

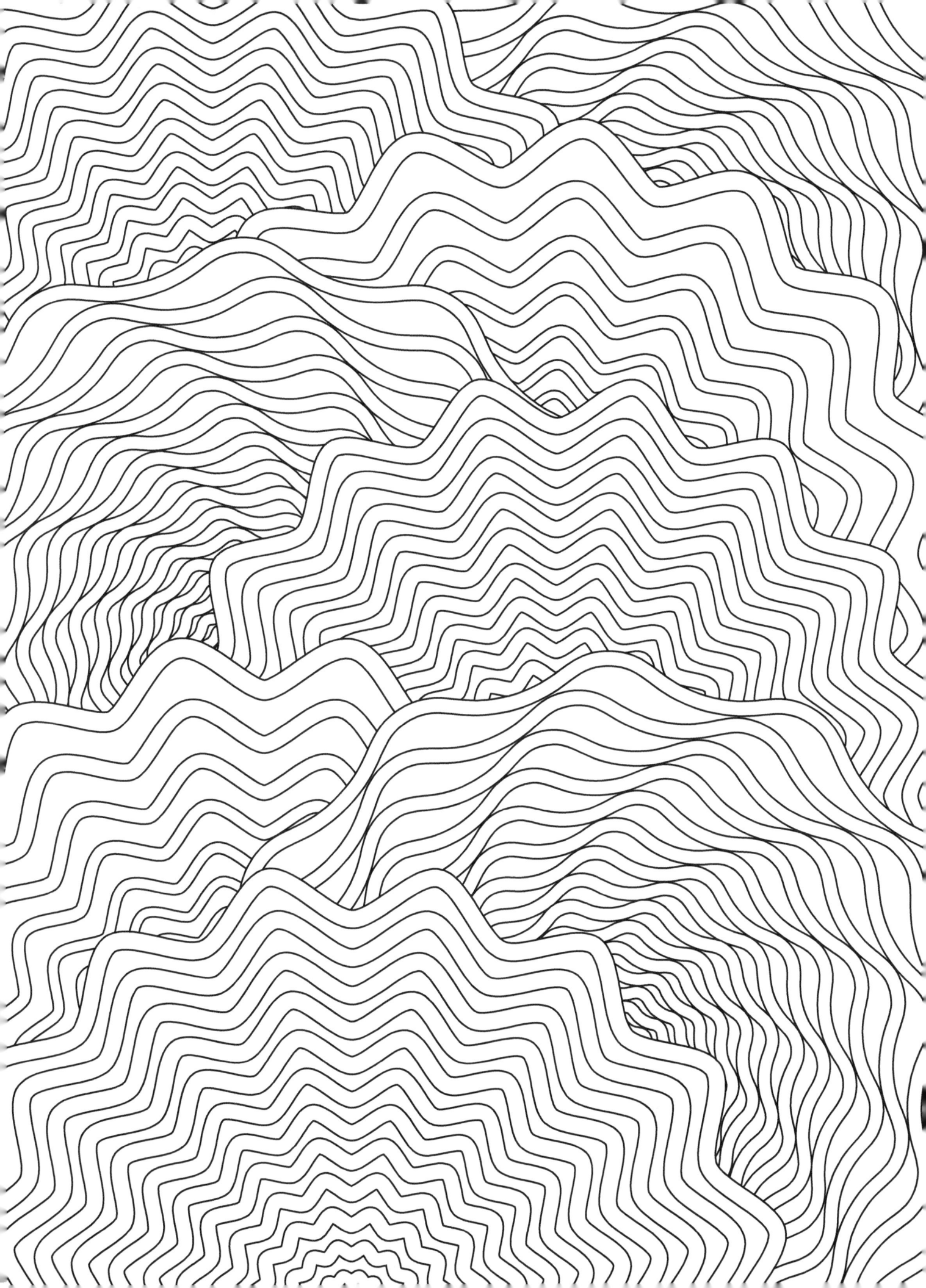

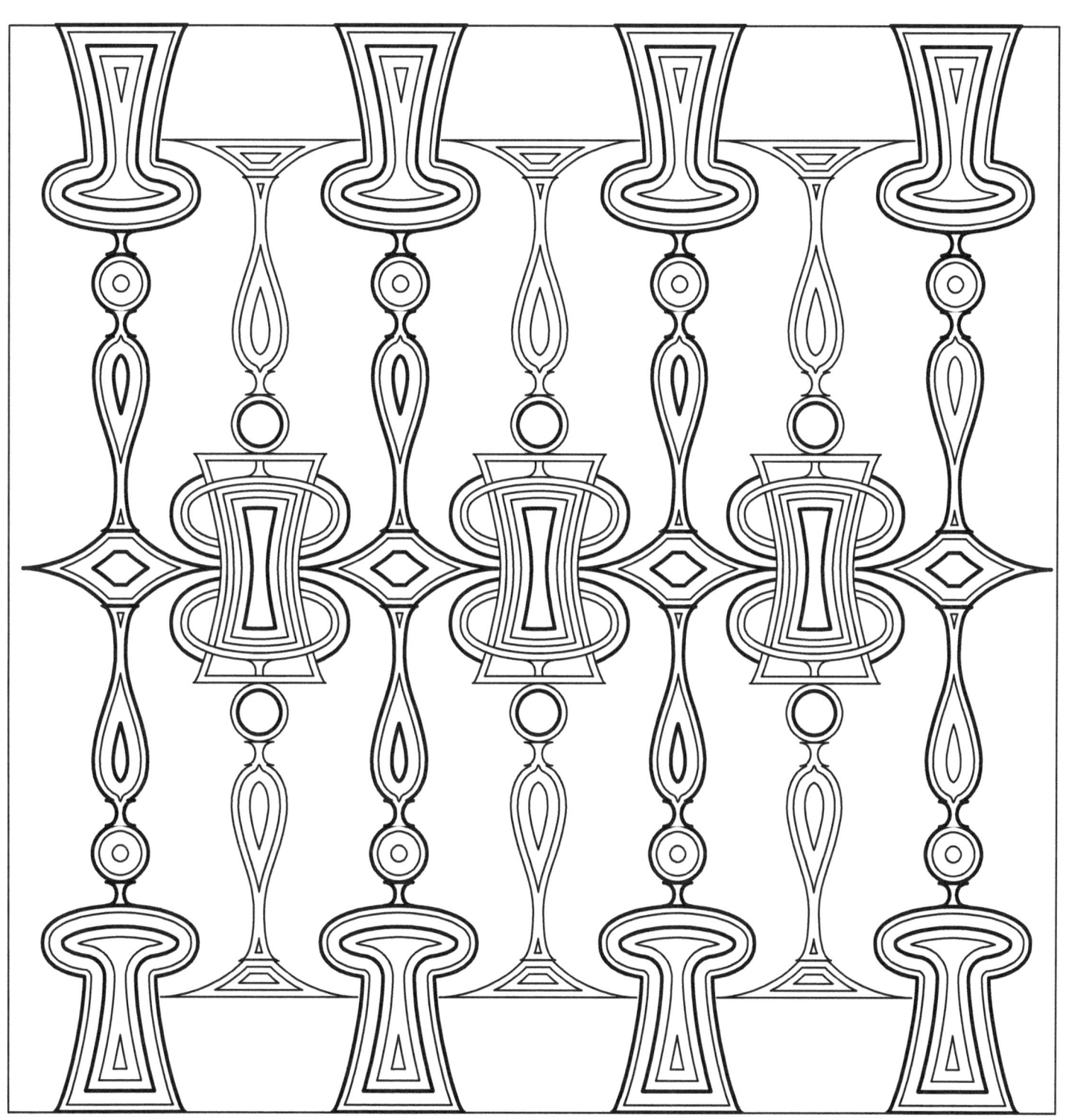

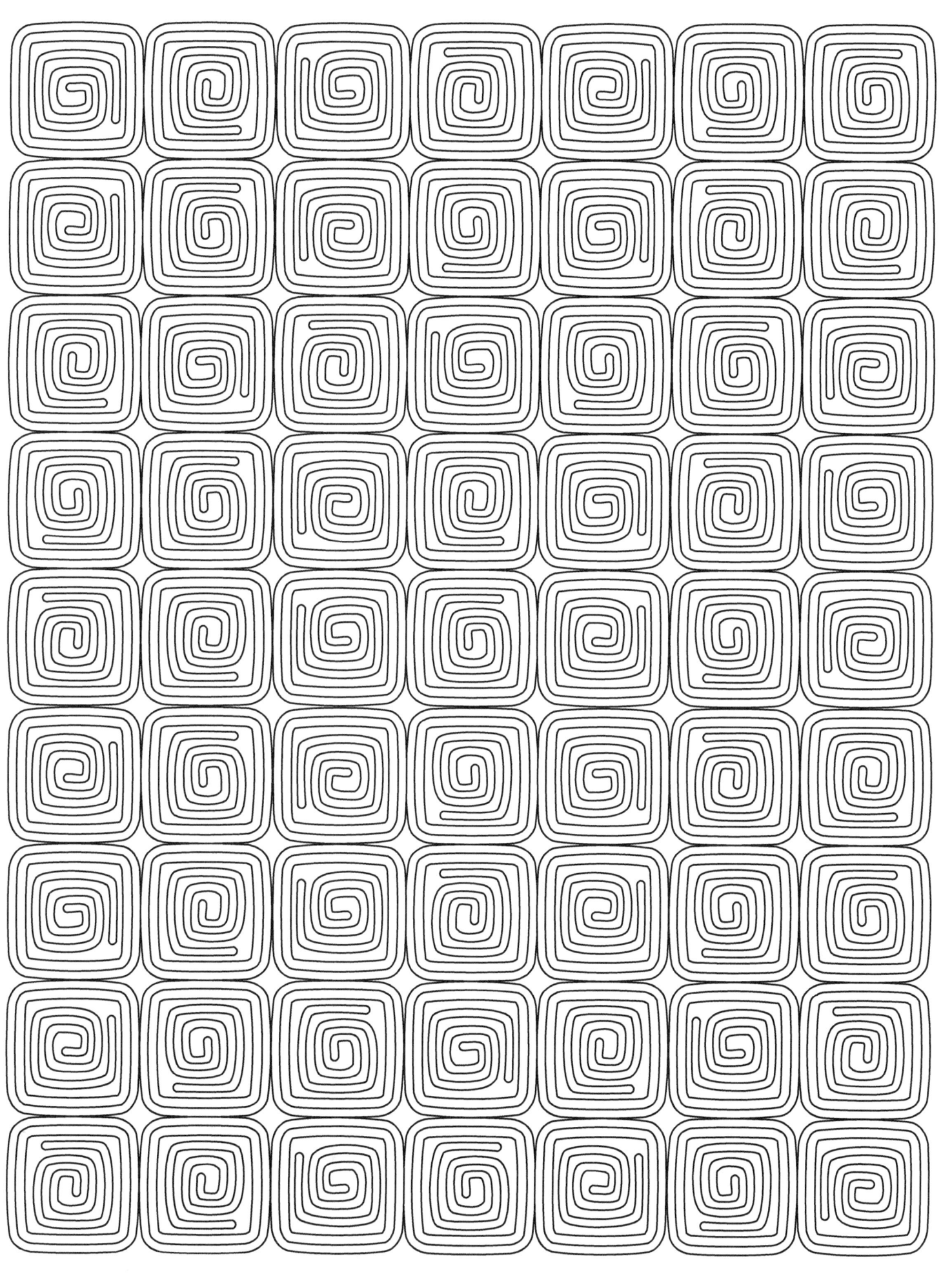

color test page

www.ingramcontent.com/pod-product-compliance
Lightning Source LLC
Chambersburg PA
CBHW081159180526
45170CB00006B/2152